CULTIVATING CREATIVITY

daily rituals for visual inspiration

HOW BOOKS

Cincinnati, Ohio
www.howdesign.com

maria fabrizio

For more excellent books and resources for designers, visit www.howdesign.com.

19 18 17 16 15 5 4 3 2 1

ISBN-13: 978-1-4403-3973-8

Distributed in Canada by Fraser Direct
100 Armstrong Avenue
Georgetown, Ontario, Canada L7G 5S4
Tel: (905) 877-4411

Distributed in the U.K. and Europe by F&W Media International, LTD
Brunel House, Forde Close, Newton Abbot, TQ12 4PU, UK
Tel: (+44) 1626 323200, Fax: (+44) 1626 323319
Email: enquiries@fwmedia.com

Distributed in Australia by Capricorn Link
P.O. Box 704, Windsor, NSW 2756 Australia
Tel: (02) 4560-1600

Edited by Scott Francis
Illustrated by Maria Fabrizio
Designed by Claudean Wheeler
Production coordinated by Greg Nock

fw
a content + ecommerce company

Dedication

For Granny and Pop, who have always had a garden full of brilliant inventions, perfect tomatoes and endless love.

Acknowledgments

My husband, Michael, has supported my every creative endeavor, and I couldn't be more thankful. I hope I can repay him: His talent far exceeds my own.

I am inspired every day by my best friend since kindergarten, Sierra Machado. She has the profound task of teaching high school art, and I know she is transforming lives more than she'll ever know.

I also have to thank my parents. They allowed me to pursue a risky path of doodling as a career and never attempted to steer me another direction.

Contents

introduction

I AM NOT A REAL FARMER OR GARDENER. I can barely keep a succulent alive. The main thing I've absorbed from carefully watching my grandparents make a garden year after year is that the process of growth is abundant.

When I was very young, my grandparents lived on a wide piece of land, great for growing vegetables and sustaining a cow or two. Even though they don't maintain the same large soil they did thirty years ago, they still pile perfect tomatoes, cucumbers and sometimes corn in my arms when I visit them. I know that the success of their garden isn't accidental. It takes year-round preparation, intuitive timing, irrigation and, most importantly, optimism.

During the fall, leaves are collected and stored in bins near the back of the yard for future mulching and spreading in the garden. The roots are dug up from the plants that have just given all summer long and the catalogs of seeds are carefully marked for ordering in the winter before spring arrives.

During the winter, I often find myself marveling at some new contraption or invention they've created to make the land easier to care for, or a new place to hang a special tool.

By early spring, they are moving the mulch around in wheelbarrows, sorting the hoses and opening the seed packets that have come in the mail.

During the humid summer, I know not to call their house in the evening. My grandmother is usually picking the vegetables while my grandfather waters the plants or stands at the kitchen sink slicing cucumbers that will soon become pickles.

I know that there are times when they are both tired and might not feel like standing in the heat, picking bugs off of

leaves or reaching for a vegetable that is too low or too high to grab with ease. But something about the process of creating things to share keeps them going, year after year.

This book is about optimism and the process of creating, with a quiet parallel to gardening. I've learned through uncounted hours of failure that creative longevity is about what you do to prepare yourself for the ripe moment, when the potential of an idea is able to grow into something useful.

I don't offer a secret formula for a successful creative crop in these pages, just the value of experimentation and intentional reflection as you work to make your task of creating plentiful. Finding satisfaction in making is about enjoying the cycle.

I started creating because of a simple, ordinary table. A Fisher-Price table and two small chairs were tucked under the twinkling lights of the Christmas tree when I was a year old, left by Santa Claus. There are countless photos of my younger self frantically drawing at the now-vintage table—gripping crayons like a caveman. The flat, smooth surface of this blue plastic object gave me the space to create. The repetitive experience of sitting, applying hand to surface and working to make something appear is nothing shy of an addiction for me. I'm a person who feels

most alive in process, where time and action are colored with opportunity.

Although I can no longer fold my legs under the tiny gift from many years ago, the memory of long hours lingering over piles of paper is a nostalgic presence when I arrive at my desk each morning. The reason I have the opportunity to share my process is because I selfishly create an illustration five days a week on my blog, *Wordless News*. The challenge of retelling a headline with only pictures forces me to evaluate my haphazard approach and to find ways to actively pursue a simple routine without becoming stale—the same way my grandparents have found new ways to enjoy their gardening routine.

So I offer little rituals of time spent away from practical deadlines. The exercises don't always end up in a final project; sometimes their value is their impermanence.

This book is for anyone who has a tendency to think visually and needs to satisfy their creative soul. It is my hope that this book offers a humble path of intentional experimentation and a new way of seeing your own visual process.

This is me, circa 1987, sporting a mullet and drawing at the timeless Fisher-Price table.

PART I:

ritual

I'M NOT ALLOWED TO CALL MY GRANDPARENTS BEFORE 10:00 A.M. They very rarely ask for anything or have limitations on visiting, but they would prefer that a doorbell didn't ring or a grandchild didn't stop by before the breakfast table has been cleared.

They follow their retirement clock and enjoy waking slowly with no rush. They are set in their quiet morning ritual. If I had to guess, I'd bet part of their ritual includes watching birds in the yard and plotting against squirrels who are eating from their pecan trees. I'm sure they take a considerable amount of time watching the weather so that they can anticipate when it will be best to tend to their garden. While their teeth brushing, dressing, eating and waking routine might be consistent, the gardener's full-day ritual depends on Mother Nature. I suspect that part of the reason my grandparents ask for peace before 10:00 A.M. in the summer is so that they can make their way to the yard and do small tasks before the heat becomes unbearable.

They also have an evening ritual in the summer. Sometimes I forget their post-dinner duties and call. The phone will ring and I'll hear my grandmother's voice on the machine and worry for a second, but then I remember that they've gone into the yard. While the cicadas sing and the frogs chirp, they work through twilight until the little solar lights come on along the path, and then they go inside to rest.

Caring for and creating their yard and garden informs their routine. They work when it feels best, when it is most efficient and when they can feel satisfied at the end of the day.

CHAPTER ONE

field notes

MY PASSION FOR WATCHING THE MOON sink into the first light from the sun is born from somewhere deep in my childhood. My parents' routine surely shaped my natural alarm clock. My father has been a morning person for as long as I can remember. He wakes up around 5:00 A.M., throws back a cup of tar-black coffee and descends the stairs to the basement where he lifts weights and listens to talk radio for an hour. My mother isn't a morning person anymore, but when she was a mail carrier she was sorting thousands of letters at the post office before most people had the chance to linger in bed after their alarm went off.

It was difficult to be an instinctively early riser as a child. I was always wide-eyed and fidgety by 7:00 A.M. at a sleepover. Among the piles of blankets, sleeping bags and junk food, I'd wonder why I couldn't just continue to dream like all the other girls sprawled about the living room floor. I used to feel self-conscious about my bird-like habit, but I've found a way to harness that restlessness and make use of the time when my mind is most active.

When I was a teenager, I started to wake early on Saturday mornings and wait for 6:00 A.M. so that I could legally escape the dormitory where I lived for the last two years of high school. I went to a public residential arts school a few hours away from my home. However, some weekends I hung around campus instead of begging my parents to drive me back and forth. Saturday mornings were the best

time to quietly crunch my way through a bowl of Cheerios and sneak up to the studios. My desire to be alone making art surely didn't come from a place of discipline; it came from angsty teenage emotions. I didn't make anything profound or beautiful on those mornings, but I'd leave the empty hallways feeling like I had a secret. I could enjoy the rest of my day because I had a sense that I had accomplished something. The act of creating—no matter what the outcome of the project—left me with a feeling of completeness and simple satisfaction.

About two years ago, I started to notice that my creativity plummeted around 3:00 P.M. It really didn't matter if I was writing an email, grading a paper or trying to sketch—my brain was about as organized as the floor of my closet. I wasn't making decisions as confidently as I would during the coffee-brewing hours. Every "afternoon idea" was garbage. I decided I should track when I felt most creative and keep a tiny creative process diary. After several weeks of taking field notes about the conditions under which I worked best, I saw that my peak happiness time was between 5:30 A.M. and noon. If I could accomplish something in that time, I felt like I was sliding down a rainbow into a bowl of cotton candy. So, I adjusted my schedule and allowed my day to be more morning and less afternoon.

First, I decided that I could go to bed earlier and get up earlier since I was naturally already an early riser, I felt that I could adjust to even earlier. I turn off my email from 5:00 A.M. to 9:00 A.M. When the world is sleeping and there are no ringing phones or email notifications, I find energy and peace.

I make a priority list the at the end of the previous work day so that I can figure out a way to balance the creative needs of a project—when it is due and when my mind will likely be most capable. I make mini-deadlines through out the day so that I don't get stuck on one thing.

Also, at some point I decided that lunch is my least favorite meal. Going out to lunch interrupts my groove, and if I eat a large meal in the middle of the day I end up just fighting off the urge to nap all afternoon—so no more fun lunches. There are a number of things I can do with that wasted time throughout the day, and I've found that long lunches just aren't helpful to my mind, body or work spirit.

I try to avoid browsing social media until after 3:00 P.M. I schedule the errands, giving myself a time limit and a putting it on the calendar so that I don't just aimlessly spend forty-five minutes in Target.

All of these little adjustments have allowed me to find room in my day. As I pushed the clock hands in my favor, I found that the sense of completion I'd been searching for was striking quite loudly, every day.

You may not be a be-bopping ray of sunshine at 4:45 A.M. every morning like I am. If you happen to find me awake at 11:00 P.M., you'll find me in a toddler state of mind, drunk from the lateness. But there are plenty of brilliant, creative people who are night owls. They crank out their best ideas and feel most energized with the stars just coming out. If you haven't yet found your best creative time and ideal working conditions, I suggest taking field notes. There will be some things you can't change about your work routine, obviously, but there are small ways you can adjust that will help you make the best use of your natural reactions to the sun dial.

24 HOUR PROJECT

↓

TOTAL FREEDOM

↓

FELT NERVOUS/
NOT MUCH DIRECTION

took
3 HOURS
for the
final idea to
BREW

— FELT EXCITED
– to have a
 meaningful
 CLIENT

SENT ONLY **1** OPTION

to the client

↓

they loved it.
NO CHANGES.

CRIED TEARS of
JOY!

STORY BOARDS

↓

This project was very quick and
kept me at the desk for a
solid __two days__.

WAS FRUSTRATED that I couldn't
find enough reference imagery
for a few of the scenes.

REALLY ENJOYED: thinking through
 the sequence of
 narrative

Really hated: How the final 2
 images turned out.
 LINE quality was
 S A D
 FELT CLUMSY

if I hadn't been overworked these
could have been better.

▫ LISTENED TO LOTS of UPBEAT MUSIC
▫ SHOULD have taken more breaks

DIDN'T FEEL LIKE
DOING WN TODAY.

I STAYED UP TOO LATE.

Wanted to cry when
my alarm went off.
Listened to mmmbop to try
and make myself more
bee-boppy.

| | | | | | | | | | | | / | | | | | | | | | | | | | | |

IT IS 3:00PM

the worst time of the day
to try and focus on a long
format document.

There are **120** Emails in
my box and it keeps
making sounds. :i

UPDATE: 5:30 PM

TURNED OFF EMAIL, Lit a candle
Got all the work done.
BOOM.

Too many changes to copy
from client once everything has
been laid out = so much grump.

□ NEXT TIME I WORK w/ this client
I will!!!!!!:
- Request Final Copy (absolute)
 before layout.
= limit the number of revisions
- back up the deadline 3 days.

□ Also, communication via email
is impossible to understand. Will
try to meet in person or call.

↓

It is easier to work on Sunday
rather than Saturday.
Just need to write that down
and remember to enforce that
thinking for the next few
WEEKENDS!

13

Keeping a little diary of my working hours has helped
me figure out when I work best, how I can better
handle projects and when my creativity peaks.

Tips for Note-Taking

I use Aaron Draplin's Field Notes notebooks to record my process. I reflect on my daily work when I feel particularly moved. I might be more tired than usual or particularly happy with an image, and those heightened emotions prompt me to consider the circumstances.

I try to look through my notes at the end of a big project to help me evaluate the level of success. It's much easier to take measure of daily projects and see how the notes are helpful, since the daily routine of creating is so similar. With longer, client-based projects, there are outside factors that I can't control and the creative process usually extends weeks or months. I try to see the project in a timeline of feelings rather than a snapshot of a single morning's routine or the bottlenecking of stress near a deadline.

These are the key things I like make note of and reflect on (in no particular order):

- The temperature outside or in the room
- My level of enthusiasm
- My level of tiredness
- Pressure, from deadlines or internal
- Any distractions I may be facing
- My level of hunger
- The time of day
- The duration of the work
- My assessment of the level of success when finished

- Whether the project was personal/for profit/nonprofit
- Ambient sounds/noise/music, either planned or unplanned
- Time spent researching
- Reference imagery
- If I recycled anything I've done previously (texture, shapes, forms, etc.)

My advice for keeping these field notes is to accrue them over time—give yourself the space to record several weeks and then study what you've noted. You'll see patterns of habit that you can evaluate and make conscious adjustments to your process where needed.

MATERIALS
- Small, portable notebook
- Pen or pencil

You can, of course, use something else besides a small notebook. Digitally recording your thoughts is helpful, too.

CHAPTER TWO

the case for coveralls

NO MATTER HOW METICULOUSLY I FOLD each article of clothing, a colorful heap always appears on my floor each morning. This chaotic tendency stems from the fact that I'm small and things never fit quite right, and because I need to be comfortable in my clothing. After starting my field notes, I started thinking about my other routines that needed some adjustment, and that's when I realized that I spent an unhealthy amount of time getting dressed.

I had a fantastic teacher in high school who wore a blue coverall jumpsuit every day. At first I was confused about why anyone would choose to wear a jumpsuit, and I wondered why she never felt the need to vary her appearance, but over time I realized it was a smart practice. It was a uniform. She didn't have to think about how she looked (she already knew), and the utilitarian design of the coverall suit allowed her to get messy and not worry about it.

As life changes, my routine will surely change accordingly, but for now I've found a way to streamline some things that can dampen the efficiency of a workday.

The Uniform

The first thing you can do to ensure you have spare moments for your work is to create a personal uniform. It can be the most stylish outfit you've ever worn or a pair of loved Levi's and a T-shirt—whatever is appropriate for your daily work. Then, put that uniform into a rotation. Maybe you have an every-other-day rotation, or perhaps you will embrace the very repetitive coverall method. Being a creative, I highly suggest you own at least two or three articles of black clothing. It might take some time to get the uniform right, and of course you'll want to adjust seasonally, but you'll be surprised by the minutes you've saved by eliminating the dilemma of choice.

Fuel

Breakfast will always be my favorite meal of the day. It always has been, and I can't imagine that changing. No matter what your creative routine, you should always eat breakfast. I could list all the studies that detail how it jumpstarts your metabolism and how eating properly really encourages your brain to work more efficiently. But I am not your mother; you surely aren't reading this to have someone tell you to eat your oats. But you should eat something. I try to be efficient about breakfast during the week, the same way I am with my wardrobe. The fuel is the same—I allow myself a short list of choices that I know will keep me satisfied, and I don't have to worry about making unnecessary decisions in a state of half-sleep.

During the day, I am more often than not lost in a world of my own, with ink and paint on my hands, completely oblivious to the fact that I haven't eaten in several hours—until it is too late. When I don't properly take a break to eat I get a migraine, or my right shoulder feels like it is on fire from sitting and working for hours and hours. Over time, through the field notes exercise, I've started the practice of intentional fueling. If I think I feel the pressure of a deadline or the excitement of trying something new on paper, I set a timer for one hour. When the bell rings I get up from my desk, I drink some water and I eat something small. Do I sound like an insane marathoner? Sometimes when my

timer goes off, I feel like one of those sweating runners in a race, squeezing packets of goo into my mouth while I pass mile markers. I've discovered that resetting my mind and making sure I'm not ignoring my body's fundamental needs keeps me sharper than when I just allow myself to fall down the rabbit hole.

Physical Activity

For several months after I started my early morning creative routine, I realized that I'd replaced long runs and deep breaths in yoga class for hours at a desk, hunched over a keyboard. The stiffness of sitting was creeping into my mind, and my body was rigid in the morning and at night. I found myself often dreading the return to my desk. The lack of physical movement was taking a toll on my body and my enthusiasm. I didn't notice how painful it had become for me to not be active like I once was.

I started consciously incorporating small physical activity back into my routine. I don't always get to take a ninety-minute hot yoga class or run several miles, but I take time to do something. Simple stretches or a stroll down the block can break up the day and alleviate the compression of my spine from sitting in a chair.

The longevity of a creative life comes from noncreative activities. There have been days when I am dressed and ready to go out to dinner and an idea strikes and suddenly I don't want to leave the house because I'm inspired and don't want to lose my momentum. Instead of canceling my plans and leading everyone to believe I'm agoraphobic, I make a note of what I'm thinking about and then I go do what I had planned. You can't create if you aren't absorbing. You have to get out and do the things you enjoy in order to find the right balance of life and your labor of love.

Even if you are just taking a stroll through the office, around the block or doing a few stretches at home, physical activity keeps you from being stale. The stiffness of sitting creeps into everything. I'm not suggesting that everyone use a standing desk or work on a treadmill, but the need to move and think while exerting something other than just your mind muscle is important.

CHAPTER THREE

keeping records

PHOTO ALBUMS ARE KEPT TO SHOW TIME passing on faces, in smiles, in hair color and in the evolution of relationships. They are cherished and saved. Now we exist in a more digital universe than the peel-back sticky pages from long ago, filled with Polaroids and curved corners.

Last Christmas my grandfather handed my grandmother a wrapped gift; she usually receives something very practical and sweet. When she opened the box, inside was a photo album with a piece of computer paper gently taped to the front. The album was titled "Grannie's Gardens." For years, my grandfather had been taking photos of her irises, flowerpots, blooming trees and vegetable garden. He had printed each photo, in color and in various states of clarity, and placed them all into a beautiful, simple photo album. This was a gift that recorded growth, labor and care over time. The album clearly showed her skill and the weather of many seasons.

Keeping a sketchbook is much like keeping an album of visual memories. You can see change over time and recall what forced that change. I believe strongly in keeping a sketchbook or journal of some kind. It might not be the kind your art director friend keeps or the kind you kept in college, but taking the time and space to record thoughts and images will help you identify places to improve and provide you with leftover ideas and inspiration for the future.

Sketchbook Selection

In my opinion, there are many are too many options for keeping a sketchbook—I've tried them all. Each offers something different, and trying out different versions of record keeping will likely help you select the one best suited to your line of visual work.

Since there are so many options, here are some ways you can narrow down what might work for your needs:

1. **SIZE:** Do you prefer working with a thin ink pen or pencil? Do you use an entire spread when you are working? Do you need something to hold a landscape, or will you just jot down doodles and notes? Do you travel a lot with your sketchbook, or does it live on your desk? Does it need to fit in your bag or purse?

2. **PAPER QUALITY:** Do you use acrylics, watercolors, oil pastels or pens that tend to bleed? Do you want to be able to see what you've written or drawn through the paper, or would you prefer to start fresh with your image? Will you need paper that can sustain any wet medium? How many pages do you need in a sketchbook? Do you work best when you draw letterforms or think modularly on a grid? Do you paste or glue things in your sketchbook often?

3. **COVER:** Do you often need a durable surface to use when drawing, or are you always at a desk or table? Do you like to write or draw on the cover of your sketchbooks, or is a textured, blank surface something you prefer?

Sketchbooks do not have to be filled with sketches. Collages, doodles, notes, quotes, blocks of color—really anything you find compelling can go in. The only constraints are ones that you impose on your own book. Just because it opens like a book and appears to have a top and bottom doesn't mean you have to follow a typical layout. It is your own record of mind and work. Make it art of its own.

This little watercolor study was done in a sketchbook with very thin paper. The pigment and water puddled on the paper, creating wrinkles and intensifying the value and density of the green. Experimenting with watercolor on various types of paper usually results in either a mess or a new way to make interesting studies with unique qualities.

The classic Moleskine page isn't bright white, which feels less intimidating than a pure white page.

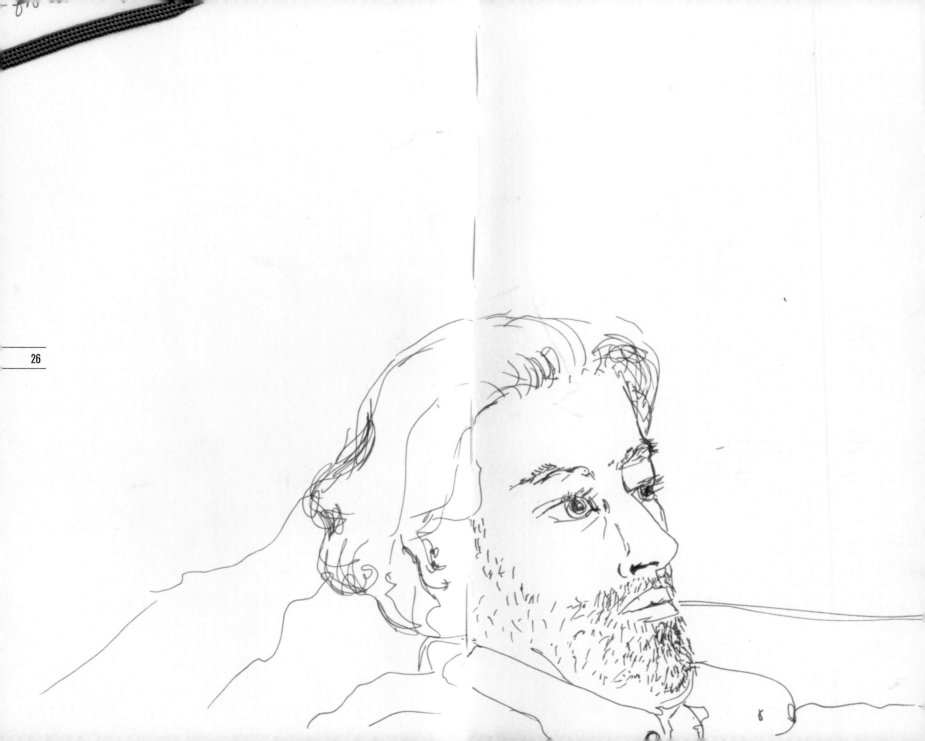

OPPOSITE: This composition uses the whole width of the spread.

LEFT: A craft paper page allows you to start with a value and work darker or lighter. White Conté crayon or chalk on the brown surface usually creates a strong but soothing contrast. This combination works nicely for figure work or objects that need to show some dimension.

gertie
March 8, 2011

28

LEFT: Even though this composition doesn't neces-
sarily make sense, the doodles use the whole spread.

RIGHT: Clearly, I enjoy recording my two animal
children in their kinetic states. These types of images
are the most common in all my piles of sketchbooks.

sock

CHAi smousero!

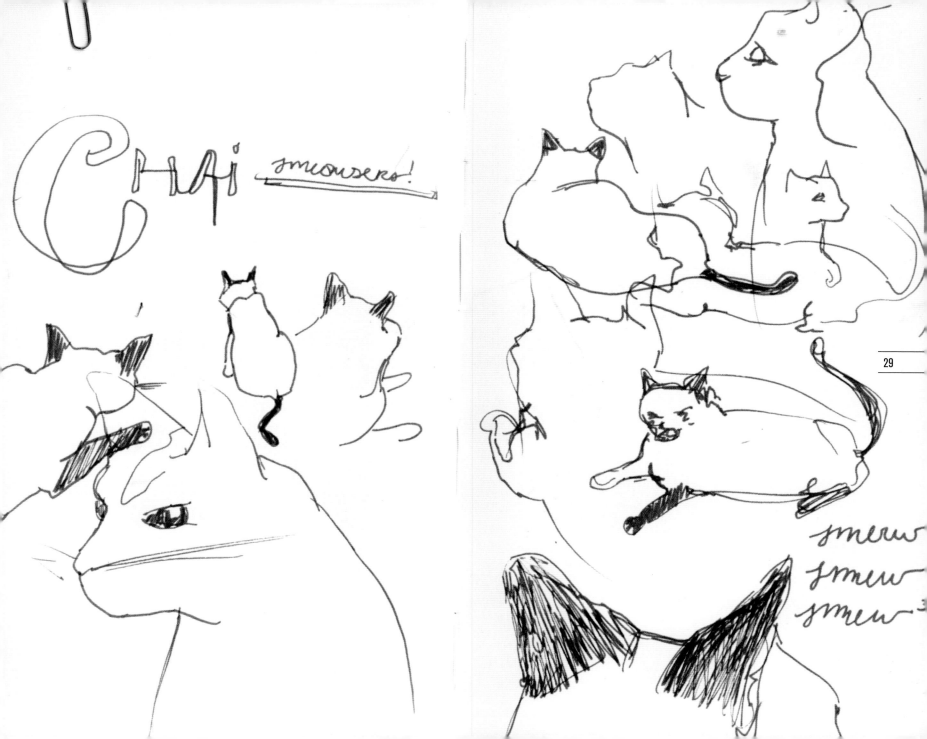

smeuw
smeuw
smeuw³

A Well-Stocked Shed

The lawn mower that jolts around my grandparents' yard is ancient in lawn mower years. It was purchased shortly after I was born, and they still get it started every other week to ride around the yard, mow the grass and pick up things for mulching. It is clearly a well-built machine. It's simple and dusty. The sight of that old lawn mower is comforting and predictable. The gears aren't easy to change; turning a corner is not at all like it would be on a more modern mower—the corners must be wide and calculated. But the lawn mower is familiar and useful. It's the biggest tool in the shed that helps with the garden.

The lawn mower sleeps in a shed that is also full of other tools. The walls of the shed are covered in old rakes, new shovels, little pairs of gloves, pots and spray hoses. Everything is neatly organized and happily lives in its place, ready to be used for a specific purpose—much like the utensils that huddle in canisters on my desk.

These tools can be used in almost any combination. Some are fairly standard and others allow for experimentation.

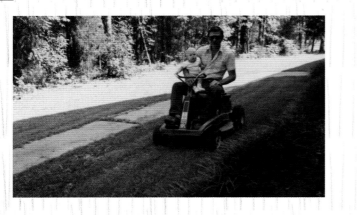

Here I am in 1986, riding along on the trusty lawn mower while Pop cuts the grass.

31

PAPER

- Watercolor paper
- Craft paper
- Brown paper bags
- Wrapping paper
- Manila paper
- Card stock
- Fabric
- Wood scraps
- Canvas
- Cardboard
- Old letters
- Sheet music
- Collaged paper
- Butcher paper
- Wallpaper samples
- Paint swatches
- Graph paper
- Newspaper
- Discarded book pages
- Acetate sheets
- Faded photographs

2-D MEDIA

- India ink
- Graphite
- Coffee stain
- Tea stain
- Watercolor
- Gouache
- Masking fluid
- Charcoal
- Acrylic paint
- Carved linoleum
- Carved stamps
- Torn paper
- Crayon resist (watercolor paint-
 ing over crayon drawing)
- Kool-Aid
- Natural dyes (beets, blueberries,
 raspberries, etc.)

UTENSILS

- Paint brushes
- Ink nibs
- Drawing pens
- Drawing pencils
- Vine charcoal
- Condensed charcoal
- Watercolor pencils
- Crayons
- Erasers
- Masking tape
- Pastels (oil and chalk)
- Potato stamp
- Found object stamps (pinecones,
 flowers, cup rims, Legos, bubble
 wrap, etc.)
- Block printing ink
- Brayer (a hand roller used for
 spreading ink)

You don't have to try all of these things or keep them in stock, but sometimes it's great to get away from the tools you use all the time. Try switching the ones you feel comfortable with for something else and explore what you can create with new tools or surfaces.

CHAPTER FOUR

safe landing

WHEN I WAS ABOUT TEN YEARS OLD, I went to visit my uncle and discovered the fun of jumping into piles of hay. I have a sneaking suspicion that if I were to do it now I would be overwhelmed by the itch of the straw upon landing, but at the time it was fun.

I would lead the way up the ladder; my two younger brothers would be close behind me. Rung after rung, we climbed on the rickety ladder until we were at the top of the little loft. Looking down, the hay would seem far away and I would always hesitate before the leap, unsure if the landing would be cushioned enough. I'd jump though, partly because of the pressure of those watching and partly because the only other way down was to climb down (which defeated the purpose of climbing up).

I think of the creative process much like those acts of youthful leaping. One minute you are at the top—the highest point, all smiles and grins feeling full of confidence and bravery.

Then you leap. You spring out and slightly up, trying to position yourself for the perfect landing.

But you might jump too far to one side or not tuck your feet the right way. The feeling of falling might not feel exhilarating when you are experience a hard thud or snapped ankle.

The risk of hurt might even keep you from the experience of the leap.

I am not paralyzed by heights, but I am shaken by the possibility of a bad fall. I've fallen many times, and I know how difficult it can be to hit the ground without that soft landing.

The key to keeping the fun in the climb and leap is making sure you have a sufficient stack of hay to fall on.

I started thinking of a way to "pile up the hay" a few years ago when someone suggested that I make a "blue book." I was feeling discouraged about everything I was making: client work, personal work, my sketches—probably even my cooking (which is completely unrelated to my profession). The "blue book" was meant to be a journal where I could write down compliments and accomplishments. When I was feeling blue or empty, I could thumb through the pages and feel encouraged.

At first it felt impossible to spend time on positive feedback. Like those depression commercials, I'm a person who allows a little storm cloud of negativity to hover over my shoulder sometimes. But I forced myself to think of even the smallest things—the words that I'd taken for granted or dismissed. I stopped allowing myself to think of the only meaningful positivity being from people in my line of work. I trained myself to truly appreciate words from anyone who took the time to say something positive, and it made a world of difference.

Practicing this method of intentional sunshine instead of rain also encouraged me to speak up when I loved

something and share the positive reinforcement and pats on the back.

Of course, there are boundaries to this way of thinking. If someone credible in my field makes a serious, genuine suggestion, I don't just turn away. Constructive criticism is essential in all areas of growth, but the vulnerability that comes with making can be quieted with even the smallest positive remark. Being optimistic about landing is key.

HOW TO STACK THE HAY:

1. To start, use a journal or sketchbook to reflect on the first memory you have of some-one complimenting your talent. See if you can recall who said it, when, where you were, what you were creating, and how you felt when you heard the positive feedback.

2. Next comb through any of your previous work—be it digital or tangible—and look for positive feedback. Decide on a way to archive these interactions. I make this practice a once-a-week ritual: Sometimes I don't have anything to add and that's okay.

3. Hunt for inspiration that perhaps didn't come directly to you. Spending time listening to TED Talks can be a great way to find words of encouragement that might prove relevant.

4. Keep this archive handy. Maybe it lives on your desk, in your laptop case or in a cloud-based app so you can access it anywhere. It's your net—you don't know when you'll need it, it just needs to be there. Next time you start to feel gravity tug your confidence downward, let yourself fall on your net. Roll around on it, spring back up and start climbing the rungs to the top again.

PART II:

intentional irrigation

THERE ARE TWO GARDEN HOSES that snake through my grandparents' garden. One eases toward the house, weaving over little chicken wire fences and flowerpots, and spurts into the bed of a tomato plant. In the evening, this hose gets gently moved from pot to pot, behind the staked vines.

The other hose faces the lake, down the yard from the garden. It waters the cucumber plants in the ground and the run-off creeps across the grass. It, too, must be moved from plant to plant so that each one is intentionally and specifically given the supply of water it needs to grow.

A hose is one way to irrigate the plants. There are two or three different-sized watering cans on the back porch near the steps that lead down to the garden. I imagine that sometimes my grandmother thinks only a few plants look a little thirsty and don't need the swift deluge of the hose. I bet she fills a can and moves from pot to pot, giving each what they need.

There have been many wet summers, months where every afternoon was a heavy dose of lightning, thunder and downpour. The plant roots were almost swimming and some of the vegetables fared better and some worse for the natural irrigation. The summers of clouds gave my grandparents a bit of relaxation and did the watering for them. It was something out of their control—just another variation.

Finding ways to water the garden is necessary. It's a routine that sustains, but the variation in this routine makes the task more interesting.

Just like irrigating, work becomes routine. Finding a rhythm is important and necessary in order to be efficient. The flip side to a rhythm is that it is repetitive, and repetition often leads to staleness. To allow the creative outcome of projects to vary and to better enjoy the sometimes-boring routine, I've introduced little experiments into my process so that the watering isn't always the same.

CHAPTER FIVE

natural selection

NO MATTER WHERE YOU LIVE OR WORK, there is a plethora of inspiration outside your window. And that inspiration is, in fact, free. Even if you travel below the shadows of high-rise buildings or daydream far from a national park, nature is accessible.

Andy Goldsworthy's work is a stunning example of how the simple act of observing and disturbing nature can create entropic waves of beauty. When you feel the rut of routine or the painful slump of your shoulders from sitting in front of a screen, it's time to get away from pixels and the hum of electricity and into the natural world.

There are five main exercises I use to access nature and to take a break from desk. The visual studies from these experiments aren't conceptual. They are simple ways to expand your pattern palette and create something new without any expectations. The value in these studies is really enjoying, seeing and absorbing the natural world.

This palette was created from just one piece of driftwood. The subtle changes in the photo from the light give a nice balance of warm and cool colors in a quiet, earth-tone group of colors.

Original Color

Set a time limit and take a walk. Maybe ten minutes, or if you know a path you love, measure that and let it keep your time. Just be sure to set a boundary so that you can stay focused. Bring a small container (bag or box) along with you so you can collect. Before you start your excursion, choose a color—any color that you might find in paint tubes. Once you've decided on what you're looking for on your mini-journey, go out and collect anything you can find that is close to the color you've chosen. At the end of your walk, lay out all of the items and document them. It might be good to take a quick photo and save it in a folder related to that color, or use the Adobe Kuler app to let the digital technology capture the color portrait. The next time you feel stuck looking for great color combinations, look back through your natural palettes and try to infuse some of Mother Nature's subtlety into your work.

MATERIALS
- A way to keep time
- Small container
- Kuler app or camera

A dried collection of flowers and a turkey
feather were the source of this particular
color grouping. Rather than pulling out the
bright yellow or the peachy orange, this
palette is made of colors of similar value.

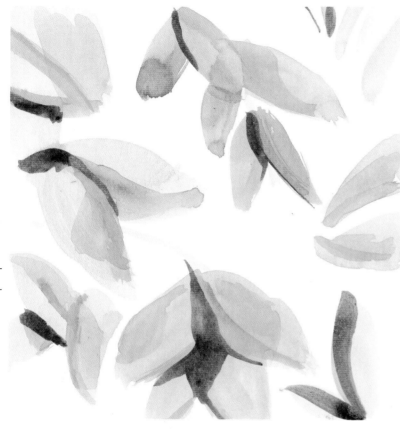

These canopy studies are of a very small section. I used a window to crop the image and tried to focus on the closest grouping of leaves.

Canopy Studies

There are many things to learn from the quiet life of summer leaves. When you look through a treetop on a sunny day, the canopy gives you a great opportunity to study the way opacity works through a variety of textures, and the way shadow creates unique shapes. I like to record these studies of the ground and the overhead canopy using watercolors. Watercolor sketches are quick, usually not very messy, and they tend to be loose—allowing for the shifting of light or the influence of wind to be present. These upward and grounded studies often allow for the creation of fun pattern and shape. I keep my studies and pull them out if I need to fill a large space in a project, add some texture to cloth or represent something natural in a landscape.

MATERIALS
- Paper
- Watercolors or a medium that is fluid and allows variation in value and opacity
- Trees
- Sunlight

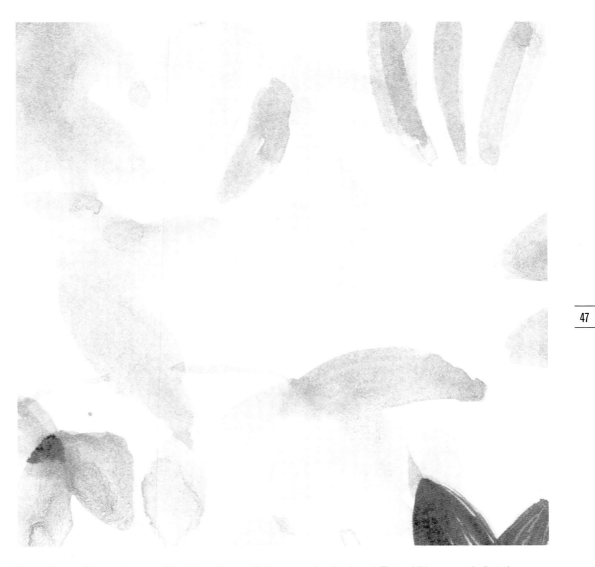

Each of these studies were done on a different type of paper with the same watercolor pigment. The top left image was duplicated several times in Photoshop, letting the top layers multiply and enhancing the dark and light areas of the green.

48

Layering many studies together digitally and using
transparency variations in Photoshop is a fun way
to create patterns and see how the shapes change
when they are combined.

Flowers

Flowers have long been a staple for representing many conceptual ideas throughout the expanse of art history. They are also simply beautiful. Flowers carry meaning and mystery, offering the chance to examine form.

Since anything I plant tends to wilt, I try to go to a botanical garden to study flowers. If I have good excuse—like a dinner party—I'll go to the store and purchase some fresh.

I like to study tight bunches (hydrangea) next to folding waves (tulips) and think about how the forms work separately and together. I often take these studies done in watercolor, acrylic, pen or pencil and scan them in for use in later projects, just like the canopy studies.

I also like to challenge myself to create flowers that feel a bit more masculine. Instead of replicating the flowers perfectly in a way that seems realistic, I like to flatten and abstract them into something unexpected. The exercise is still about looking and seeing the beauty in the simplicity of flowers, but the stylization creates a fun challenge and unexpected outcomes.

MATERIALS
- 2–3 parts of a flower
- Paper
- Scanner
- Medium of choice

These flower studies were created using some small petals. I applied ink using a brayer to damp paper. The petals blocked the ink on the paper, creating little impressions of their organic edges and shapes.

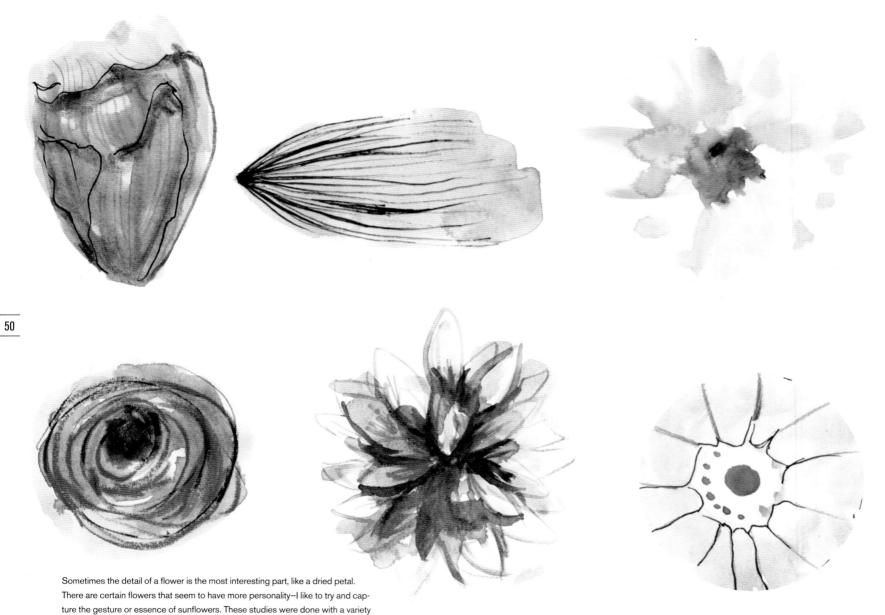

Sometimes the detail of a flower is the most interesting part, like a dried petal. There are certain flowers that seem to have more personality—I like to try and capture the gesture or essence of sunflowers. These studies were done with a variety of techniques, including watercolor, pen, marker, crayon, oil pastel and pencil.

The Detail of Nature

Mother Nature has a variety of skin types. From the curling of birch bark to hard red clay, everything we know to be true about fabricated material has been influenced by what already exists on Earth's surface. When I feel especially stuck on a conceptual idea, I attempt to think about scale in the natural world to help move me in a different direction. The smoothness of a stone is hard to convey out of context, but if I take a huge sheet of newsprint and attempt to draw this pebble, how do I reconcile the detail with all the space?

Sand or dirt is a great thing to explore in detail, or over a large surface. It is miniscule but makes up so much foundation. Upon first glance, it appears yellow or brown, smooth or even. However, if you sift through the grains, you'll reveal all sorts of color and imperfection. Whether you choose to show something realistically or in a simplified, general way, looking closely offers clues into the variety of visual elements in the most basic parts of nature.

Fall leaves have an interesting and wide variety of color variation. When studying them up close, you can almost see the colors bleeding and turning.

LEFT: Using a wash, crayon and pen, this study is a detail from the bark of a crepe myrtle tree.

TOP: This watercolor study is the detail from the inside of an oyster shell.

BOTTOM: This is the outside of the same oyster shell. It has a similar color palette, but the shell detail is added with simple pen lines.

Puddles

Puddles are mysterious. Sidewalks create irregular pools of murky water sprouting weeds; dirt roads allow congregations of stamped footprints and potholes left from a winter's snow to become baths for daring birds in the spring. Puddles are fleeting, but they linger long enough to study. I often use puddles as a mirror to the canopy study. The muted reflection in puddles crops the objects above in an interesting way and allows for unexpected negative space. If the conditions are right, I take a sketchbook out into the humidity after a rainstorm and just draw the shapes quickly, trying to capture four or five puddles at a time. While this probably causes neighbors and friends worry about my sanity as I hover over something that appears to be nothing, it gives new meaning to negative space.

Sometimes I find these studies creeping into things I work on for clients, but most often the small, quiet act of recording puddles just brings me a sense of peace and a sketchbook full of very surrealist imagery.

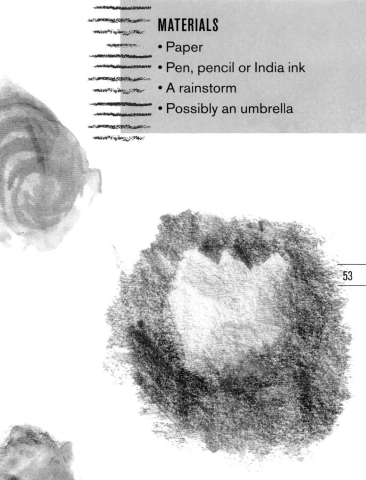

MATERIALS
- Paper
- Pen, pencil or India ink
- A rainstorm
- Possibly an umbrella

I find that most of my puddle studies turn out fairly abstract. Sometimes I'll see a limb or shape of a tree emerge from the final sketch, but the value of the puddles is the zen that comes from reflection.

CHAPTER SIX

perfect conditions

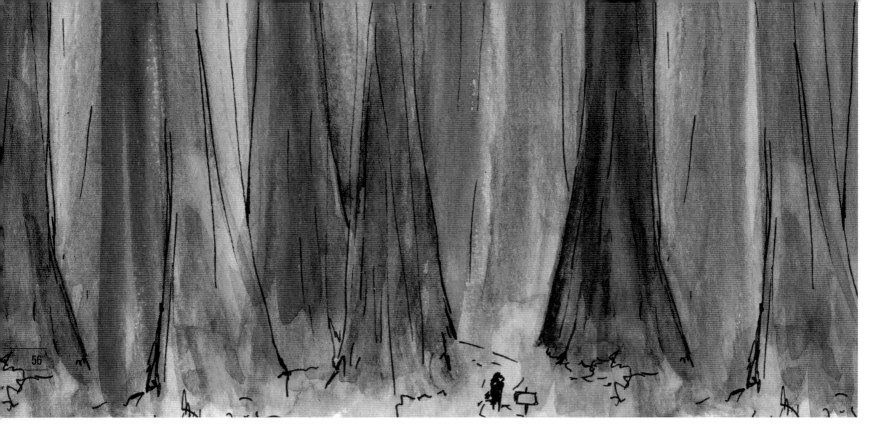

GIANT REDWOOD TREES tower in the coastal parks of
California because the rolling fog slows the rate of evapo-
ration of moisture from the soil. Plants that have thrived
for hundreds of years have the opportunity to continue be-
cause the environmental conditions provide some advan-
tage. This natural process produces mysterious and trea-
sured things that can be easily missed, despite their ma-
jestic size. If you drive the Pacific Coast Highway and don't
stop to walk around, they whirl by in a blur, unseen.

The creative process also offers the opportunity to grow
something unexpected in the right conditions.

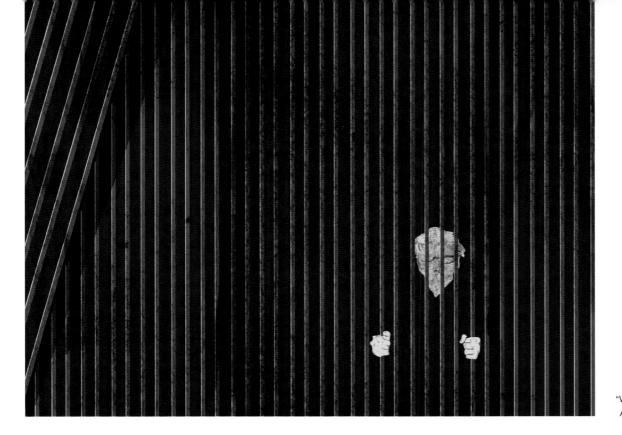

"Whitey Bulger" from *Wordless News*
August 13, 2013.

Early on, when I was working on my blog, *Wordless News*, I decided to capture the Whitey Bulger sentencing. All I could think of was an old man in jail—a literal, boring interpretation that just kept appearing in my mind. I wanted to reveal something else, but couldn't find the right visual. I sketched him with his hands on the bars, emerging from the dark, and just kept staring at it, unsatisfied with the flatness of the image. I got up, tossed my pencil on my desk, got a cup of coffee and came back to the sketch. My pencil had landed at an angle across the lines of bars, and suddenly I saw the lapel formed by the shape of the pencil. The bars holding him back were no longer prison bars but the pinstripes of a mobster's suit. This accident wasn't really an accident: It was an opportunity to see the possibility of something more than I had first thought.

Following are three main techniques I use when I am trying to realign my conceptual direction. Be aware of how various conditions produce different results.

MATERIALS
- Old magazines, photographs or things you've made in the past
- X-Acto knife or scissors
- Rubber cement
- Surface on which to adhere the collage

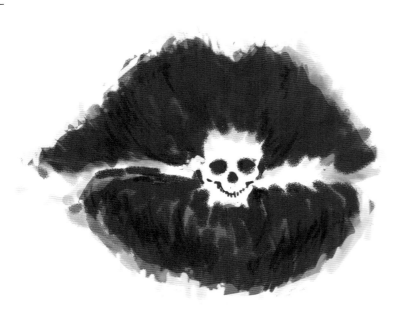

Juxtaposition

I've found that the conceptual accident is most often borne from the principal of juxtaposition, and I've tried to consciously work that into my process, when possible. It's important not to be forceful but intentional. If I'm working on an editorial illustration or trying to express something provocative, I list out various points in the story or the assignment.

Then, I think about those items and decide which ones are visually worth showing and I start to sketch them. Looking at various figures, poses, scenarios and objects can be overwhelming, so I cut them out and begin to arrange them in various ways. Can a button be a face? Can the left-over lipstick from a kiss hold an image? Can I bury one of these into another or use the negative space they create to make something new?

By spending a little time questioning if there is meaning between unrelated objects, something usually emerges that is useful for the conceptual meaning of the work. More often than not, a fun animal creature emerges just because I'm taking time to cut, arrange and glue.

"Dangerous Lipstick" illustration from *Wordless News*, August 21, 2013. This article was about the danger of toxic metals in some lipstick colors and brands.

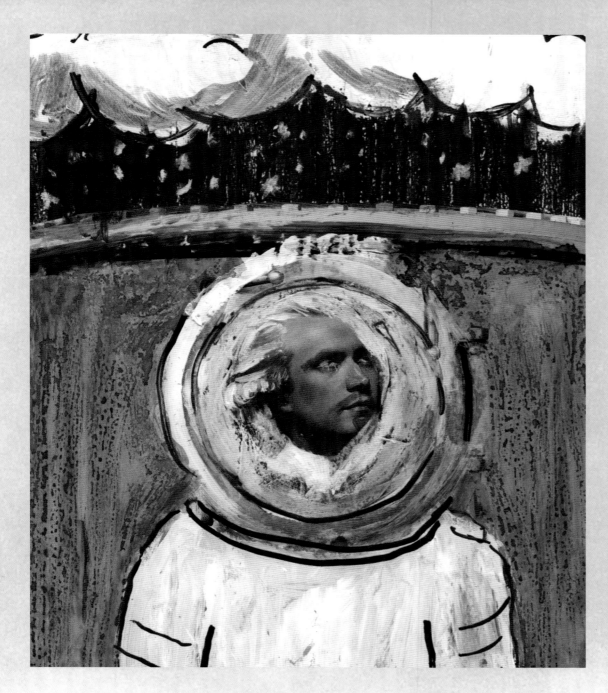

This is just a little experiment from a sketchbook. The background image was a large metal tank with a porthole on the front. The porthole made me think of being underwater. I found a classic portrait and added it to the round circle and used acrylic paint, India ink (black and blue), yellow and blue crayon and Sharpie to tie all of the elements together. The final image evokes the idea of an explorer in some type of suit, perhaps in space or possibly underwater.

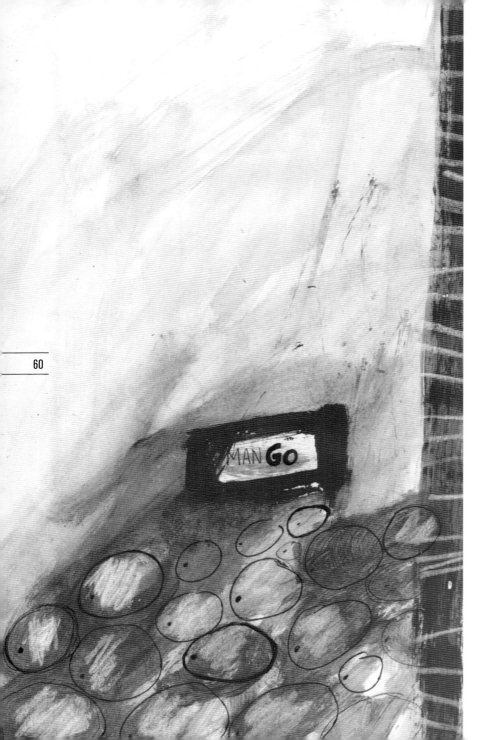

Thinking Like a Kid

There is great joy in the act of returning to materials from childhood. The slickness of finger paints, the tacky sound of a crayon and the dust of chalk feel so fundamental to me. In using those materials, there is no judgment and just making and exploring.

Most of the time when I attempt to make something halfway beautiful out of these materials, it ends up looking about like it did twenty-five years ago, when my coordination was like that of a goofy puppy. So the piles of these little experiments either take me to a conceptual revelation, or are scanned for textural use, or they end up in the recycle bin. When the freedom of working with unrefined materials hands me something that might take me in a new direction, it gets neatly taped into a sketchbook with the other project documents.

This started out as just a red wash on some old paper. The less saturated areas began to lighten, and so I added an orange color (using my finger). This messy doodle sat in a sketch book for several years, and when I came back to it the color combination made me think of mangos. I added white oil pastel and black pen and gave the scribble some context. The expression of the lines and variety of color weren't intentional, but I've used this texture in the background of many illustrations since I first created it.

MATERIALS

- Newsprint
- Newspaper
- Butcher paper
- Colored paper
- Construction paper
- Charcoal
- Crayons
- Chalk
- Acrylic paint
- India ink
- Cheap markers

Sometimes a nice way to have a mental break is to grab things nearby and some cheap acrylic paint and stamp away. Put on some zen music and see how different things interact with and handle the sticky paint. This snippet is made from a wine cork, a toothbrush, a thumb, a paintbrush, a leaf and a stick.

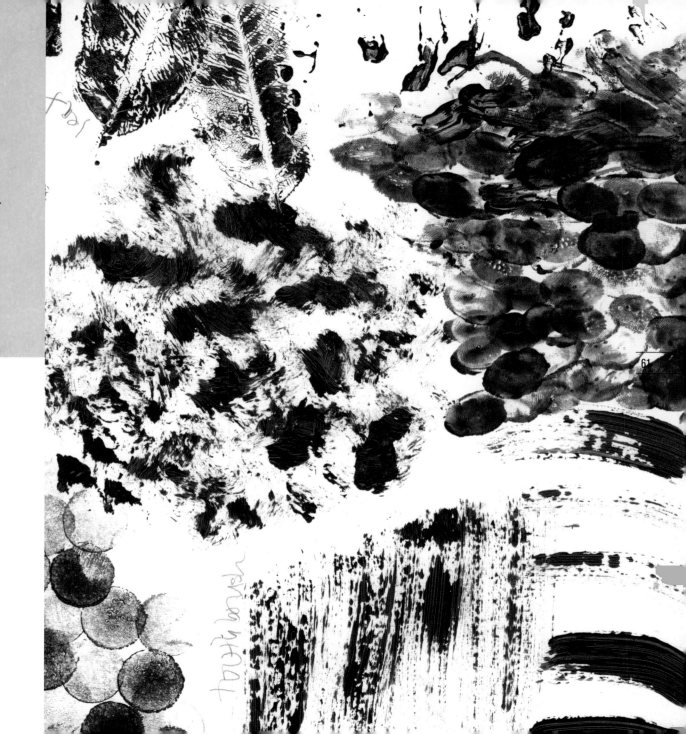

61

63

LEFT: India ink markings on super smooth paper.

RIGHT: There is something therapeutic about just making texture and seeing brushstrokes; no direction—just repetition.

Restating

Showing and saying the same thing on a billboard or in an illustration leaves nothing for the viewer to explore or discover. Restatement of the obvious doesn't often inspire, but recreating a statement that is unusual or provocative inspires the fantastical.

"Astronauts Shrink-Wrap an Asteroid." When I read this headline (prior to reading the article or listening to the segment on *Morning Edition*), I giggled. It sounds like a ridiculous scenario—two astronauts floating through space attempting to tightly wrap an enormous rock? I decided to illustrate this literally because I knew it would be fun and would create an image that was memorable. The final visual looks like something an eight-year-old might want on her wall, dreaming of a superhero career.

I like to call this method of visual problem solving "fantastical reality." Even though the scenario you're visualizing might be impossible, if you find a way to visually represent an idea simply, with a little twist, sometimes the visual can unlock new meaning to a familiar idea.

Here are a couple of ways to start thinking like this:

- Think of a scientific principle and try to make it understandable for a child. Try to think of three ways to explain it in a way that feels tangible, informative and fun.
- Explore three scenes or scenarios from old fables or nursery rhymes; often these images come easily because they were present when you were forming your visual vocabulary as a child. Revisiting them allows you to see them in a new light.
- Find images from very different magazines or sources and combine them in a similar fashion as the juxtaposition exercise. Try to force two things together that look different but come together to create one meaning.

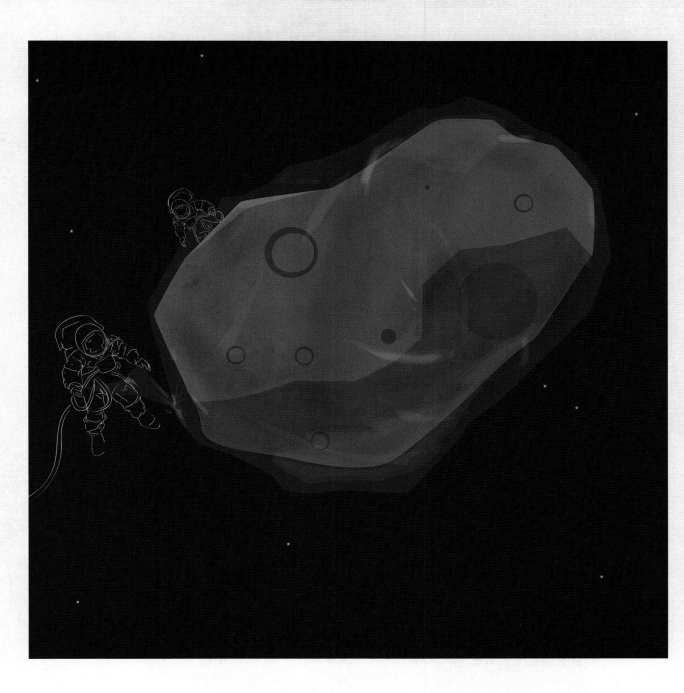

Even though the thought is ridiculous, the image ends up being fun. Here, two astronauts are shrink-wrapping an asteroid.

This *Wordless News* illustration was created to show the start of Shark Week. Instead of the typical rabbit ears coming from the TV, there is an ominous fin and the screen has turned blood red. This image represents the gore that takes the main stage during Shark Week, as well as the fantasy and the way the week-long event has become such a big part of our TV culture. This image was finished digitally but most of the texture was created by overlaying scanned textures made of charcoal, watercolor and acrylic paint.

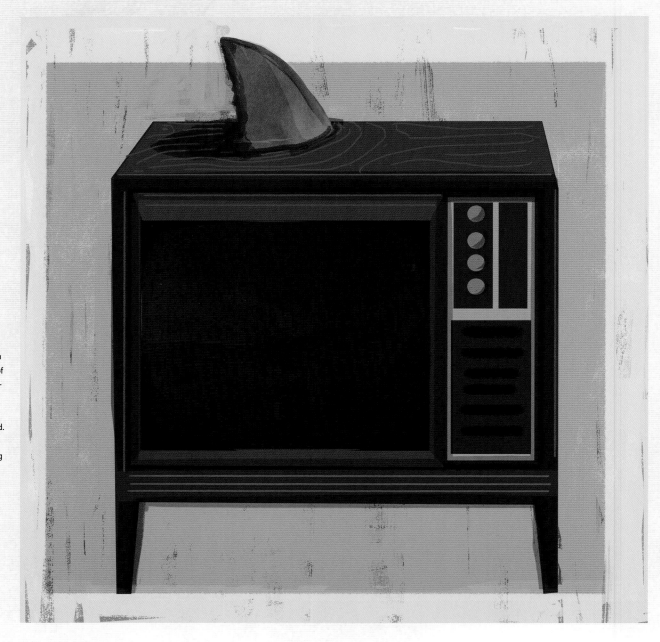

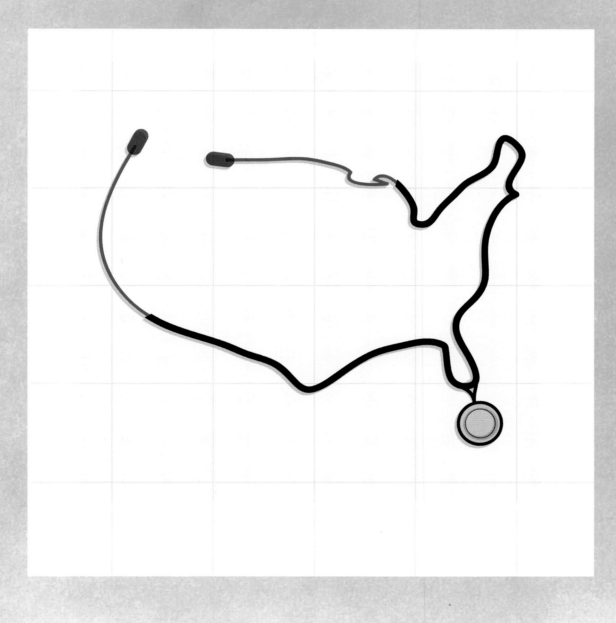

This *Wordless News* image appeared when the Affordable Care Act launched. Using the most simple and recognizable icon of our healthcare system, the stethoscope, I was able to create a little outline of America.

People love going on cruises. I, however, will never step foot on a ship after reading story after story of illness and desperation on the seas.

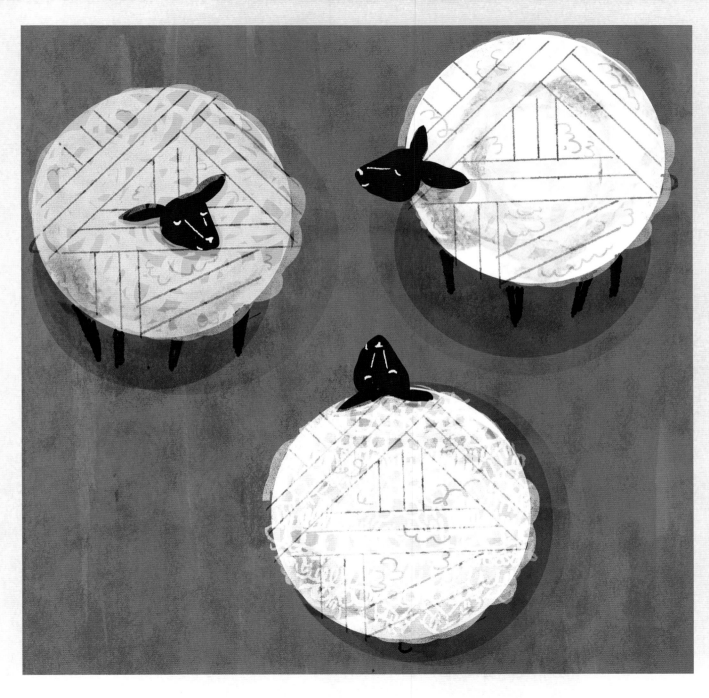

Using the general shape of the sheep and adding some line quality and texture, this illustration emphasizes the idea that yarn comes from the sheep's coat—without showing how that process works. The concept relies on the the image being so literal that it is unexpected.

This was the first *Wordless News* image
I created. I wanted to find a way to repre-
sent the Pope retiring. This simple vector
illustration of his hat on a coat rack
seemed to be an easy way to say that.

Recently, a Pentecostal preacher died after being bitten by a venomous snake. The prayer hands double in meaning. They represent the occupation of the victim but also the action that was his quest for healing. This piece is mostly digital, with the exception of the yellow in the background and the brush strokes on the body of the snake.

The Magic of Erasing

Walking into the bathroom in college after an art class, I would often find large smudges of charcoal, graphite or chalk on my face. Completely absorbed in the act of drawing, I wouldn't realize how ridiculous I must have looked until the class was over and I had carried on a conversation or gone through an entire critique with a mustache. Sometimes just being absolutely covered in a material is freeing— and it's a great place to start a project.

I've always found drawing by subtracting or erasing a bit difficult, but very rewarding. First, you start off with some type of paper, usually fragile newsprint. (I can't count the times I would be carefully covering a sheet with value from some tool and rip a hole right in the paper, and have to start over.) You'll want to create an even dark coating across the paper, using a medium like charcoal or pencil. It takes concentration to create an even value across the paper. Charcoal is the easiest medium to use in my opinion because you can smudge it with another piece of paper or tissue to get the paper properly covered. Once your paper has gone from white or off-white to black or dark gray, you're ready to start.

The eraser becomes your drawing tool. Instead of dark lines you start to see white shapes, and the more you erase, the more you reveal. Working backward tricks you. It makes you think about the lighting from dark to light. The eraser in your hand gives the illusion of everything coming from

somewhere dark and mysterious. The only way to "erase" what you've drawn is by smudging the value of your original medium back onto the paper.

Trying this exercise with a still life or model of some sort is best. If you can control the lighting of your situation, you will probably have an easier time getting the objects close to how they appear.

73

ABOVE: This is a cropped image from a large still life drawing. The white areas are from a cloth bag. The finger prints from smudging the black area are visible in the scanned image. The drawing was made on a very thin paper and the white created by slowly erasing the thick charcoal.

RIGHT: This cropped figure study is an erased drawing with charcoal quickly blended on a toothed paper. I went back to the drawing after all of the figure had been completed with eraser and added in detail, using quick lines of darker charcoal.

CHAPTER SEVEN

pack rat profiteering

EACH CHRISTMAS MY GRANDPARENTS put some-
one's gift into a box that's been reused again and again.
The box is small, about the size of a set of note cards. It is
worn but still sturdy. It has a beautiful vintage illustration
of vegetables on the top lid. Aside from that, it's just a box
that seemed like it might come in handy again. Almost thirty
years ago, they saved it and started wrapping it each year.
Now, my whole family tries to guess who will find the box
tucked inside bigger boxes and bags each year. This re-
sourceful repurposing of the old box has helped me accept

my emotional attachment to material items—and realize that
the source of that tie is rooted in visual thinking.

I have always been able to admit that I have hoarding
tendencies. Actually, my entire graduate thesis started with
my messy desk and all the junk I had tucked away in my
apartment. I do believe this struggle isn't a lonely one; many
designers and illustrators deal with this problem. It's hard
to get rid of things you once spent time with, felt connected
to or see some potential use for in the future, like the Christ-
mas box.

The Personal Library

When I die, there will likely be a disturbing amount of black sketchbooks in various stages of completion to be thrown out. I've been saving my sketchbooks as long as I can remember. The ones from high school (which I hope no one ever looks through) are saved largely for their content. Many of them appear to be more diary than sketchbook—pages filled with horrific figure drawings and Fiona Apple lyrics. The longer I save sketchbooks, the more I find them valuable for my current process, and the harder it is to let them go.

I often flip through my own history and look for a forgotten idea. It's not often that I see the exact image I'm looking for, but the curve of a line or the shadow from a still life might give me a clue to a composition. My personal library of failure and lost ideas is a source of inspiration and a reminder of the upward trajectory of my efforts.

Old works are often very useful for scanning in and using as textures or recreating color schemes that worked long ago.

It can be overwhelming to save everything, and definitely not for everyone. I highly suggest scanning and digitizing items when you can, or finding beautiful ways to store things so that you aren't tempted to throw everything away the next time you have to move somewhere.

A snowy scene made from India ink and white oil pastel on a gray paper. Several years ago someone gave me a stack of these rectangular gray sheets, and I've been making little doodles on them ever since, slowly making my way through the stack. The trees were just from my imagination; my only intention was to see if I could create a winter scene using the paper color as a starting point. I've used this imagery in several pieces since it was created.

Masking fluid is a great way to create white space and block out areas before applying watercolor to an image. I started this little nighttime sheep image with some scribbled and blobbed areas of fluid. This is taped into a sketchbook, and I often sample texture of the sky for other illustrations.

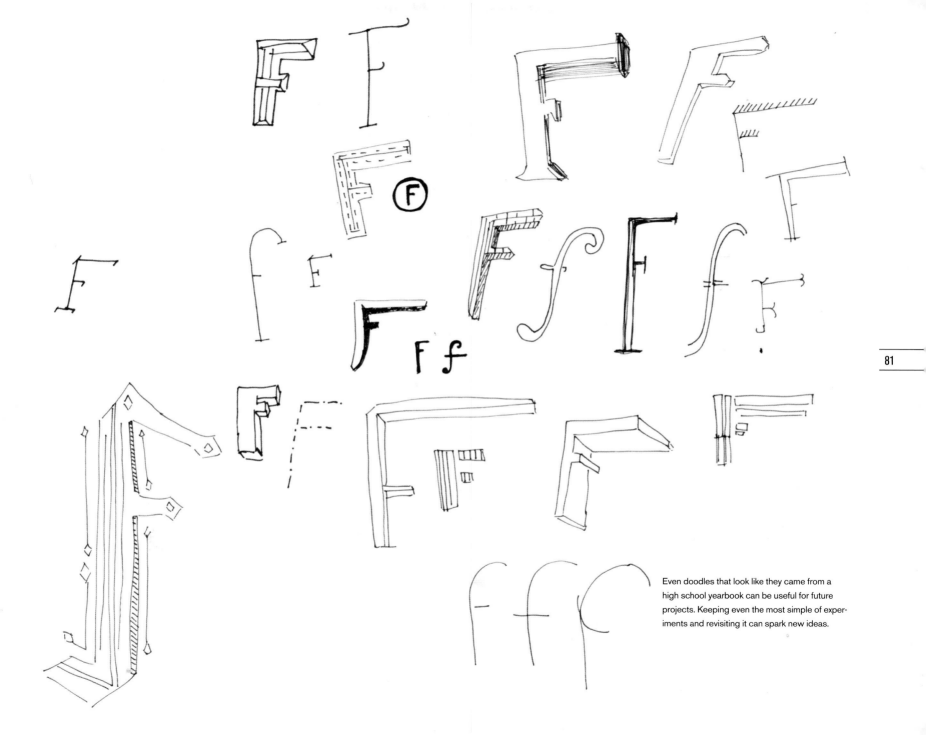

Even doodles that look like they came from a high school yearbook can be useful for future projects. Keeping even the most simple of experiments and revisiting it can spark new ideas.

Flipping through old sketchbooks can also remind you of ways to work. This sketch's value is created through simple line quality, which is something I haven't tried in a long time.

I love to use pages left empty in sketchbooks
for collages or weird little experiments. This
piece came in handy when I needed a pattern
for a piece of clothing in an illustration. I simply
scanned this in and used it, rather than creating
something new for the piece.

Not every page is going to seem useful. There are pages I wish I could rip out so that my track record would look perfect in each sketchbook. But then, in the corner of a rejected page you might see something worthwhile and useful—like these pearls.

Sketchbook Archive

You already know I believe in using a sketchbook. When I taught classes, I always made the students keep one for the semester, and I'd give them a grade at the end of the term for the depth of the sketchbook. It's important to think things through and keep record of what you see.

If you tend to use scrap paper, find a way to organize it. The growth of your mind over time tends to leave little brilliant ideas behind and you may find them useful in the future. Saving your past work also provides content for your "blue book" and allows you to reflect on how you've changed. Growth is visible when you have pages to prove it.

Find a way to dog-ear important images or ideas from the pages you once found blank.

Simple bookmarks can help you organize all the documents, or you can scan things you feel are particularly noteworthy for later use. Make sure to name the scans in a way that you will find exactly what you're looking for later.

If you use sketchbooks that have a spine, I suggest labeling them with the year so you can know what to expect before you dig in. If you have spiral-bound books or ones without a spine, you can try to organize through color coordination or a special tag on the front.

These are just simple white gift tags from the craft store. I often tape these on the top of a sketchbook page that I want to mark as important. The design around the top circle lets me know what type of image I'm flipping to find.

These were little prints I created with cut linoleum, over ten years ago. I saved all of the rejected test prints thinking I could use them as cards. The image is weird and not great, but I scanned each of these in and was able to use the unique line quality for prints in client work.

I created these prints many years ago as well. Instead of preserving each stage of the process like the black and white prints, I added marker, pen and pencil to these and made them each a little different. There was no intention behind these variations other than the desire to see how the shape of the tub reacted to the stripes and solids. These have been so helpful in creating unexpected texture for projects.

Riches Under Dust

If I always had a free hour during lunchtime, I'd drive a few miles to an antique mall and give myself the freedom to explore. The musty, damp smell of forgotten treasures from other lives can be off-putting, but those dimly lit corners and objects quietly collecting dust are important—even if they appear decidedly ignored. An eerie silence usually hangs in the air around ancient stereos and unused postcards in little plastic covers. I find inspiration in the history of modern relics. The mystery behind the previous life of an object makes it seem important.

There can be value found in the heaps of rejection at the antique malls and thrift shops. Retro color palettes, fading typography and stylized instruction manuals are visual lessons about past success. My marriage would probably end if I decided to haul home all the things I've loved in antique stores, so I try to find ways to document the experience without actually bringing everything home to collect more dust. Sometimes finding treasures in thrift shops takes getting up to your elbows in clothing or old bags that smell like moth balls. It isn't always pleasant, but when you take the time to hunt you might find a few surprises.

MATERIALS

- **SKETCHBOOK:** You can take quick notes or sketch little items you like in a store; no one will run over and ask you to leave… usually.
- **CAMERA PHONE:** Truthfully, there have been times when I've found something I really wanted to bring home, but I couldn't get it in the car or knew that I might regret the purchase later. I always ask politely if I can take a quick photo of something so that I might see if it will be right for my home or whatever purpose.
- **KULER APP:** This is a great resource if you're just looking for new or different color combinations in retro pieces of artwork or advertising from long ago. They can be easily captured with a quick snapshot.

Dining Room - Xmas crystal on
desk. recognize copper tea kettle?
Further outside window
row weighted down with snow.
two windows on other side

Taken from our side porch
looking back of house —

Bad Wiese
A8108

House to
right of us —

Wele's
daughter, "Suzy"

Bad Wiese
A8108

Jack took this standing
behind Engineer on trip to
Berlin.

Bad Wiese
A8108

These are the kinds of things you find hidden in an antique store. These are the
faces and places of strangers from a distant past. Strangely, I found these on
a cold January run. They were just lying in the grass, curled and fading from the
weather. I stuffed them in my pocket and have saved them for several years. Their
mystery is fuel for any type of creative imagination.

Stylized Relics

My grandmother gave me her old sewing machine to use as a desk when I went to graduate school, and tucked inside was the Singer manual. I remember opening the drawer one day, finding those instructions in perfect condition and feeling so grateful to her for saving them. The line quality used to draw the hands is absolutely perfect. The curves of the fingers, the angular shapes of the sewing foot and the delicate typography couldn't be recreated. While my personal style doesn't lean toward the beauty of this manual, when I study it I feel the need to refine my lines and clean up my curves. I also find myself looking for an excuse to attempt to create something in this way and anything that warrants envy is worth saving.

When I find some of these relics, I ask myself these questions while I'm studying the visual quality:

- How is negative space used?
- What type of perspective is being shown?
- How is the color palette limited?
- How is the line quality of a drawing or design different from my own way of working?
- If I had to guess, how was this created?
- What would this look like if it were created today?

STYLIZED ITEMS TO SEARCH FOR:

- Instruction manuals
- Boy Scouts manuals
- Old advertisements
- Illustrated books
- Postcards
- Stamps

PARTS and their FUNCTION

Before using the buttonhole attachment, inspect it carefully so that you will know exactly how each part operates.

A. Lock — Keeps template retainer plate in place.

B. Adjusting Knob — Controls position of cloth clamp.

C. Cover Screw — Holds cover in position.

D. Cover — Conceals working parts of attachment.

E. Fork Arm — Straddles needle clamp in order to move attachment.

F. Adaptor — Part that fits on presser bar.

These are my favorite details from the sewing instructions from my grandmother.

mounted slide, you may need to readjust the automatic focus for the different slide film.

Loading tray

Check the bottom of the tray to make sure that the LOCK is engaged in the NOTCH; if it is not, turn the metal bottom plate until the lock and notch are engaged (see Figure 1).

Turn the lock ring in the direction of the arrow marked UNLOCK; then lift off the ring (see Figure 2). Insert a slide into each slot in the tray, with the top of the picture down.

EKTAGRAPHIC Slide Trays

Has two compartments which will accommodate three trays, or a lesser number plus extension cords, lenses, and other miscellaneous equipment. Available from your photo dealer.

To order additional index cards (up to 25), order part number 216130 from

Eastman Kodak Company
Central Parts Service
800 Lee Road, Rochester, New York 14650

VIOLENCE
AND YOUR CHILD
by Margaret Mead

94

This is a Kodak projector manual, more sewing details and a guide to television from 1959. Vintage is so clean and simple.

Material Value

Collecting textures and patterns can easily be done via Pinterest, but nothing compares to the experience of feeling the leather of an old trunk. I try to take photos of textures that are particularly wonderful for documentation. Having a great camera helps, as does being discreet if you aren't purchasing anything from this house of junk.

These are the main items I look for when I'm digging for textures to study:

- Trunks
- Furniture
- Lamp shades
- Picture frames
- Tabletops
- Quilts
- Beading

Pictured are a burlap sac, the metal back of a projector and old graph paper.

Source is ancient story of India 500 B.C

THE PARDONERS TALE

Heere folweth the Prologe of the Pardoners Tale

Radix malorum est Cupiditas: Ad Thimotheum, sexto.

"Lordynges," quod he, "in chirches whan I preche,
I peyne me to han an hauteyn speche,
And rynge it out as round as gooth a belle,
For I kan al by rote that I telle.
My theme is alwey oon, and evere was: 5
'*Radix malorum est cupiditas*.'

First I pronounce whennes that I come,
And thanne my bulles shewe I, alle and some.
Oure lige lordes seel on my patente,
That shewe I first, my body to warente, 10
That no man be so boold, ne preest ne clerk,
Me to destourbe of Cristes hooly werk;
And after that thanne telle I forth my tales;
Bulles of popes and of cardynales,
Of patriarkes, and bishoppes I shewe, 15
And in Latyn I speke a wordes fewe,
To saffron with my predicacioun,
And for to stire hem to devocioun.
Thanne shewe I forth my longe cristal stones,
Y-crammed ful of cloutes and of bones; 20
Relikes been they, as wenen they echoon.
Thanne have I in latoun a sholder-boon
Which that was of an hooly Jewes sheepe.
'Goode men,' I seye, 'taak of my wordes keepe;
If that this boon be wasshe in any welle, 25
If cow, or calf, or sheepe, or oxe swelle
That any worm hath ete, or worm y-stonge,
Taak water of that welle, and wassh his tonge,
And it is hool anon; and forthermoor,
Of pokkes and of scabbe, and every soor 30
Shal every sheepe be hool, that of this welle
Drynketh a draughte; taak kepe eek what I telle.
If that the goode-man, that the beestes oweth,
Wol every wyke, er that the cok hym croweth,
Fastynge, drinke of this welle a draughte, 35
As thilke hooly Jew oure eldres taughte,
Hise beestes and his stoor shal multiplie.
And, sires, also it heeleth jalousie;
For, though a man be falle in jalous rage,
Lat maken with this water his potage, 40

56

THE PARDONER'S PROLOGUE 41-87 57

And nevere shal he moore his wyf mystriste,
Though he the soothe of hir defaute wiste,
Al had she taken preestes two or thre.

Heere is a miteyn eek, that ye may se.
He that his hand wol putte in this mitayn,
He shal have multipliyng of his grayn, 45
Whan he hath sowen, be it whete or otes,
So that he offre pens, or elles grotes.

Goode men and wommen, o thyng warne I yow,
If any wight be in this chirche now,
That hath doon synne horrible, that he 50
Dar nat, for shame, of it y-shryven be,
Or any womman, be she yong or old,
That hath y-maked hir housbonde cokewold,
Swich folk shal have no power ne no grace
To offren to my relikes in this place. 55
And whoso fyndeth hym out of swich fame,
They wol come up and offre on Goddes name,
And I assoille hem by the auctoritee
Which that by bulle y-graunted was to me.

By this gaude have I wonne, yeer by yeer, 60
An hundred mark sith I was pardoner.
I stonde lyk a clerk in my pulpit,
And whan the lewed peple is doun y-set,
I preche so, as ye han herd bifoore,
And telle an hundred false japes moore. 65
Thanne peyne I me to strecche forth the nekke,
And est and west upon the peple I bekke,
As dooth a dowve sittynge on a berne.
Myne handes and my tonge goon so yerne,
That it is joye to se my bisynesse. 70
Of avarice and of swich cursednesse
Is al my prechyng, for to make hem free
To yeven hir pens, and namely unto me.
For myn entente is nat but for to wynne,
And nothyng for correccioun of synne. 75
I rekke nevere, whan that they been beryed,
Though that hir soules goon a-blakeberyed!
For certes, many a predicacioun
Comth ofte tyme of yvel entencioun;
Som for plesance of folk and flaterye, 80
To been avaunced by ypocrisye,
And som for veyne glorie, and som for hate.
For, whan I dar noon oother weyes debate,
Thanne wol I stynge hym with my tonge smerte
In prechyng, so that he shal nat asterte 85
To been defamed falsly, if that he

Here is an old book back in kelly green, notes made by a stranger in a purchased version of *The Canterbury Tales,* and the back of a wooden cigar box.

On the left is the blue, scratched bottom of an old sewing box; the side of the box sports a lovely woven pattern. The material on the right is the back of an old etching plate.

CHAPTER EIGHT

blind contours

IN HIGH SCHOOL, I WALKED INTO A 3-D CLASS and the instructor handed me a blender. It was torn apart; wires exposed, buttons missing, the glass askew—a mess. He then passed around dark charcoal and pads of newsprint and instructed us to start drawing our various destroyed objects without looking at the paper. I had long been familiar with the unpredictability of blind contour drawings, but I had no idea what the practice was teaching me.

We all started drawing quietly. The student next to me very obviously tilted his head down, taking a long gaze at his newsprint. I could feel my face go red as he was plucked from his seat and dismissed from the class with an incomplete assignment for the day, for looking at his paper. I was afraid of also being humiliated, so I kept my eyes on the blender as my uneasy hand wandered around the page. After three long hours, I had used all of the sheets of newsprint. I had looked at the destroyed blender—almost unblinking—for an afternoon, and when I set the object at the front of the room upon exiting, I saw it in a completely different way.

Blind contours are a way to change perception and knowledge; they adjust our ways of seeing. The perspective of an object in space becomes something elusive in the overlapping of lines and undetermined shapes. The exercise employs imagination, faith in your ability to see and understanding of space. People often say, "I wish I could draw," or, "I want to learn to draw." Blind contours are absolutely the best way to start or further the process of learning.

Typography

Hand-lettering the entire family of Helvetica is a worthy and tedious introduction to typography at many colleges. My version of this exercise is created by doing blind contours of various typefaces that are similar to each other. This helps me understand their subtle structural differences. Blind contouring letters is something you might do to pass time on plane or when you're on a long car ride. The outcome is the value of time spent inspecting.

These are selections from a blind contour alphabet.

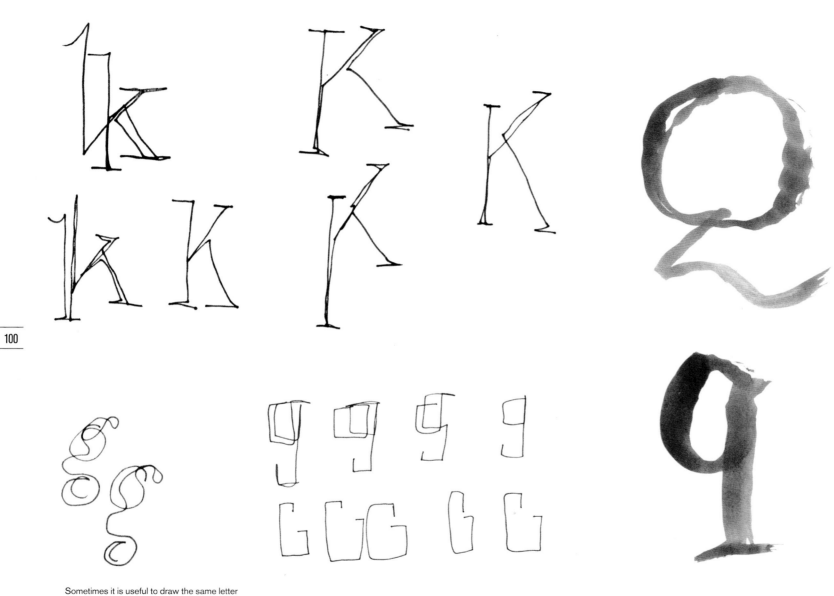

100

Sometimes it is useful to draw the same letter
from different alphabets in a variety of media.

Animals

My cat is quite fat and happy. She lazily rests on the back of the couch in the evening when I'm watching television, becoming the perfect fluffy statue. Our dog also loves to curl up across the room or stretch long across the floor, which gives me the opportunity to draw something more defined than the softness of my purring companion. I have quite possibly spent more time looking at my pets than at the face of my own mother, because they are always available to model. The drawings that emerge from my pet observations are things I will surely cherish when the pets themselves are no longer snoozing nearby. If you have your own pets, I'm willing to bet you won't find a more readily accessible model for your studies.

Chai, the fat cat, in blind contour.

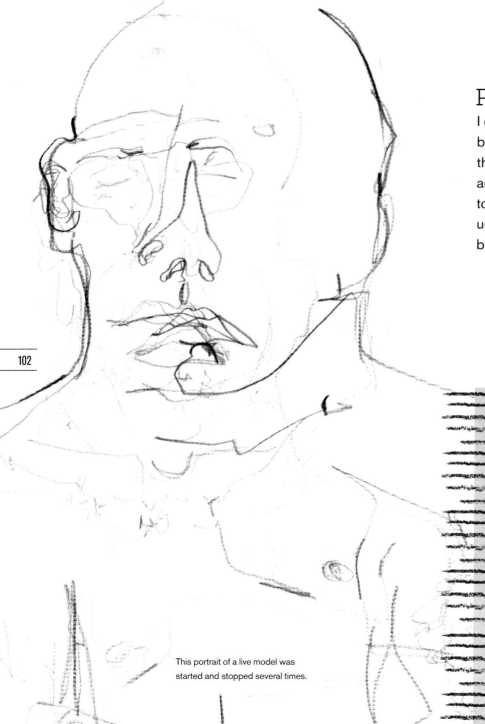

This portrait of a live model was
started and stopped several times.

Portraits

I don't often have the chance to draw anyone but my hus-
band, but I do believe that every time I draw him, I see some-
thing new about his face. Little sparks of personality pass
across faces all the time and we miss them because we're
too busy getting the proportion right or worrying about val-
ue structure. I think the best way to capture a soul is with a
blind contour, only looking and not harboring expectations.

Materials
- Sketchbook
- Pens (you'll want a permanent way to draw;
 blind contours don't allow for erasing)
- References (books, magazines, or exam-
 ples of letterforms) for typographic blind
 contouring
- Animals (if you don't have a furry friend, you
 can always spend an afternoon at the zoo)
- Friends and family who may be snoozing on
 the couch

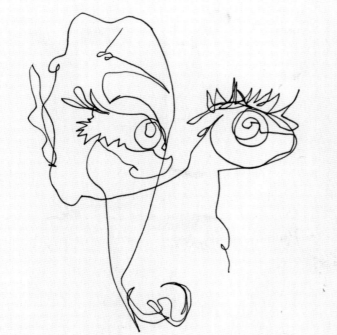

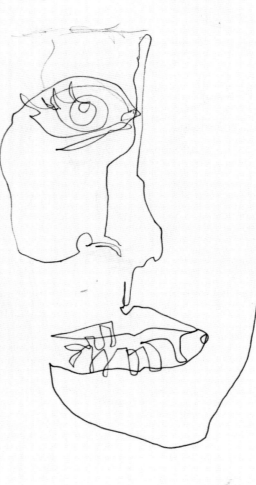

Less can be more when working on blind self-portraits.
You learn what you tend to see, what you know about
your face, and how your features work together without
trying to force it all together and put a bow on it.

CHAPTER NINE

scale

THERE IS SOMETHING MAGICAL about thinking big. I more often find myself thinking small, however. When my hands are cramped from holding the Wacom pen or my feet are restless, I approach my chalkboard. If I hadn't stumbled upon a large metal sheet already installed in my studio I would probably just use the sidewalk or a big sheet of butcher paper.

The motion of "swopping" your arm to create something that will look unperfected from most perspectives is freeing. Just as the blind contour exercises encourage new ways of looking and translating, this shift in scale does the same.

The best thing about working analog on any experiment is that there is no undo button. Command + Z will not magically clean your surface so you can start over. The key to ensuring you don't waste time working on a grander scale is to step back. Walk away for a few minutes, return, look at the project while closing one eye—all of the traditional techniques.

Created Puzzles

One of the very first projects I recall working on—in a group—was a grid project (I think it was Van Gogh's self-portrait). The image was broken into a perfect grid and each of us were handed a little square to recreate. When we were all finished, the image was puzzled together and you could see the way that working small and alone created something new and collective when pasted together.

I've always loved taking something apart and rearranging it. Lincoln Logs, Legos, leftover scraps on a plate—really, anything that can be reimagined has potential to be something new. I try to take things from my sketchbook or doodles and photocopy them so I have something new to work with in the destruction phase. I use a ruler and pencil to grid out the image and then use an X-Acto knife to cut it into squares. Once I have all the pieces, I just imagine I'm working on a visual Scrabble game, and I create something weird and new. Sometimes the value in this exercise is the process of cutting and making something new. Other times I find little details in things I couldn't have found otherwise.

ABOVE: Three-color wood block print of bluebirds.
OPPOSITE: I copied this image on the copier and then cut it into small squares. I rearranged the image without a specific purpose, just so I could see how shapes started to work together, and also to see how the image read when there was no context to parts like the beak or wing.

MATERIALS
• Grid paper
• An image to deconstruct
• Ruler
• X-Acto knife
• Surface on which to experiment

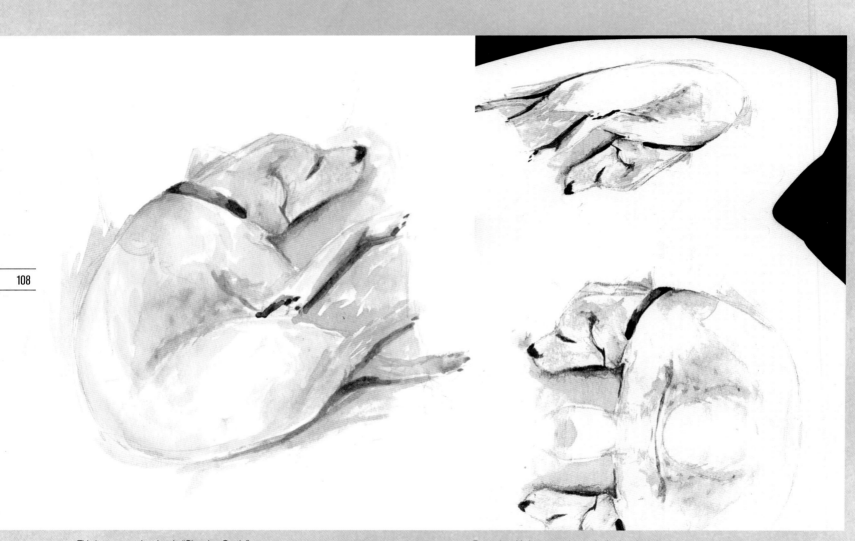

This is a watercolor sketch, "Sleeping Gertie."

By setting this image on the copier bed and moving it around while the light moved, I was able to mirror and distort the sketch. This is a fun way to look at your work from a new value and motion perspective.

Copier

There is a musical quality to a Xerox machine as it scans from side to side, light sweeping across a paper, clicking and humming, until out pops a little clone. The technology is somewhat simple, but there are numerous ways to use this necessary office machine for experimentation.

I like to abstract imagery in three ways using the copier:

1. Leave the top open and place an image (or any-thing, really) onto the bed of the scanner. As the light moves across your image, move it from side to side or slowly drag the image to move with the light. You'll see what comes out as something elongated or distorted with a trippy feel. The line quality you can achieve by moving something on the scanner can be a great way to deconstruct the value of an image.

Moving paragraphs of type around on the scanner bed creates psychedelic-looking phrases and can morph alphabets into awkward characters and new shapes.

109

RIGHT: This snippet of a stamp collection was something I snagged at the antique mall. To get a better look at the detail and texture of each stamp I could have just scanned them in at a high resolution and studied them, but I decided to use the copier as a method of looking and exploring.
BELOW: I enlarged the scan and then scanned in the enlargement, letting technology add its grain and distortion.

2. Take something with texture or line quality and make a copy at 100 percent. Then take the copy and copy that, but enlarge it by 50 percent. Once that copy comes out, continue to copy each of the subsequent images until you have something no longer recognizable. Try to find something interesting by letting the process happen very organically.

The final enlargement is just this section of Washington's face. This scan of an enlargement shows the typographic details, the precision in the line quality of the drawing and the details of age and use from the postal service.

3. With the tools of Photoshop and Illustrator, it is very easy to instantly create contrast within an image, but with the copier you have less control over how the grain of something appears and how intense the contrast will be. I love trying to discern negative and positive space in an image by letting the copier make it black and white and by bumping up the contrast.

Large Letters

Even if you aren't a type nerd, visual thinkers can always appreciate the perfection of a shape. When learning about typography in school and doing wild experiments with projectors and typographic phrases in graduate school, I always noticed how perfect type became when it grew and was cropped into something abstract. A numeral 5 could become four segments of negative space if it grew and was taken to the edge of a surface. Since I'm a person that works in the digital world very often, I can easily open Illustrator and scale type up and down to create interesting forms, but what I find more inspiring is to use a copier or scanner to enlarge handmade type into something even more abstract. Bowls, swashes and stems can become components in a composition that has nothing to do with typography.

Here are some letters created on large paper using India ink. I looked at various typefaces while creating these—but not with too much detail or restraint.

ABOVE: By placing the letters on the copier and simply randomly enlarging the shapes, new compositions emerge and detail in the value structure of the India ink show up.

RIGHT: After taking a second look at some of the cropped letter shapes, you might see other images show up. I turned this curve into the neck of a bird and the face of an alligator.

CHAPTER TEN

compost

THE COMPOST PILE ALWAYS SEEMED like a disgusting term to me. It made me think of rotting eggshells, flies, leaves, dirt—general nastiness. In reality, compost piles are smart and useful. They make your plants happy, alleviate waste from landfills and return nutrients to the soil. My grandparents heap their grass, leaves and other assorted, appropriate trash into the bins toward the back of the yard to make useful soil for the next year. The bins are large and impressive: They have wooden slats that lift from the front so that as the pile becomes less of a heap they don't have to reach and bend to receive the compost. It's one of the many inventions they built using old pieces of wood they had leftover. Under the top layer of grass, if you wiggle your hand into the deep center, it's warm. You can feel the chemical reactions happening as all the organic matter becomes something else, and all in all it is a fascinating thing to observe.

The Pile

I have a flat file solely dedicated to interesting paper. I open it every so often to find inspiration in texture or color, but I often use it to make something new. I call this collection my compost pile. The pile includes but is not limited to:

- Wrapping paper scraps
- Music sheets
- Wallpaper samples
- Handmade paper
- Paint swatches
- Graph paper
- Newspapers
- Old letters
- Paper grocery bags
- Advertisements

Keeping this collection could seem like another way to hoard, but I do have a rule for the compost pile. If I want to add something new, I must use something that is already there. I often run these papers through my printer or doodle on them to send as birthday cards or notes. Sometimes I'll scan the paper and use it in a client project, but then I toss it in the recycle bin and it leaves the flat file. The great thing about keeping this collection is that I'm never short a surface to experiment on.

Here are some items edited
from the compost pile.

Personal Retreat

In graduate school I had semester long workshop called "Adventure." It revolved around two lists of words that seemed unrelated and random. The first set of words were nouns such as *cicada, rock, river, tree, pencil, blade, flower, branch, knot, grain*, and so forth. The other corresponding list was made of verbs adjectives such as: *float, light, race, small, roll, skip,* and *loud*. The entire semester (the grade) revolved around finding ways to visually represent these words together. The lists were equally long so essentially our task was to pair them up and create something based on their combination that represented the two words together.

At the time it seemed a little like busy work—really enjoyable busy work, but I couldn't see where these random combinations of words, materials and ideas were taking me. Looking back, those hours spent working through those carefully created lists were some of the best things I've done for my own process. It just took several years for me to understand the value of having no intention—of just creating and letting the result reveal itself as something useful.

I take a day every three months and call it an adventure retreat, and I work through my own set of lists, which rely heavily on my compost pile. I take the essence of the adventure workshop and turn it into a little more an adventure with materials. The materials and the surfaces might vary based on what I'm keeping, but I try to always make time for this exercise. I start by making a short list five words, nouns, and I create each of those five words using a set of tools on a set variety of surfaces. Just like many other experiments, what comes out of this retreat is the satisfaction of completion and the break from the intentionality of practical work.

For this particular adventure retreat, one of the words I wrote down was *feather*. The materials I was experimenting with that day were a graphite stick, oil pastel, India ink and watercolor. I made each of these on a page torn from an old book.

CHAPTER 13

Kathy sat down on the floor beside her sister, and Danny squatted with them, resting his head against Kathy's shoulder and yawning with his mouth stretched wide. The lamps flickered in pools of light on the smooth-grained floor, and the silence beat in waves of pressure against their ears.

MATERIALS

I try to collect enough paper so that I can cut them into similar sizes and am able to experiment equally on each one.

PAPER

- Wrapping paper
- Cardboard
- Paint swatch
- Newspaper
- Book pages
- Sheet music
- Handmade paper
- Atlas or map
- Manila envelope
- Brown paper bag

MEDIA

- India ink
- Graphite
- White acrylic paint
- Crayon
- Watercolor
- Charcoal
- Oil pastel
- Sharpie
- Conté crayon
- Colored pencil

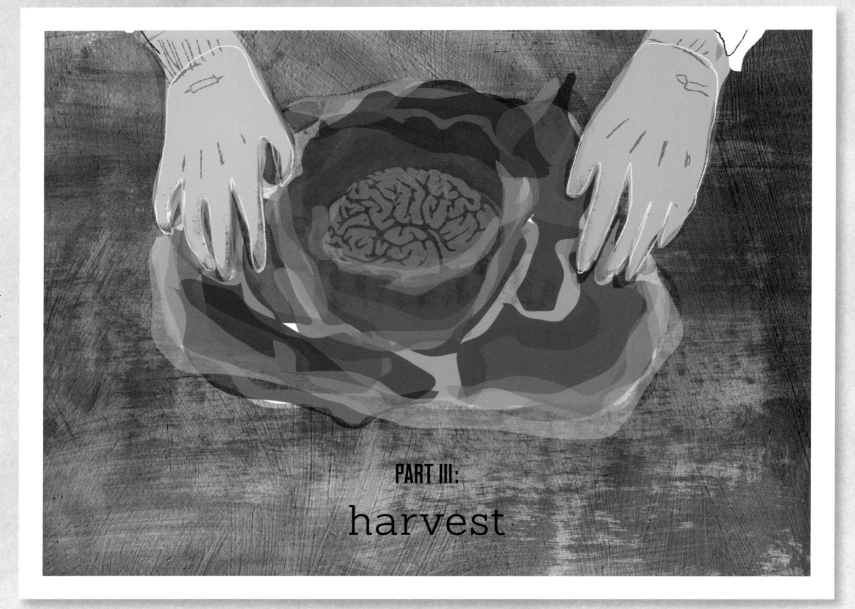

PART III:

harvest

DURING LATE SUMMER, I consume an alarming amount of BLT sandwiches. I eat them because I want to properly use the tomatoes that my grandparents have grown and picked and given me. They pass them to me in cardboard boxes or little plastic buckets just about every weekend. I let them rest in my kitchen window and when they are perfect cardinal red, I know it's time to slice them. I marvel at them in the days before they are sacrificed between two slices of bread, crispy bacon and fresh lettuce. They are a harvest. They took months of work; a year of preparation, really.

I enjoy every bite. The satisfaction of using them for their intended purpose is great. When I finish a project successfully, I am reminded of the tomatoes. The result of a piece is the harvest. The work of experimenting, thoughtfully recording, failing and being curious culminates in something satisfying. The process can be difficult and tedious and exhausting but it can also be enjoyable.

CHAPTER ELEVEN

escaping

I'M A TERRIBLE TRAVELER. I overpack my bags. I end up with wrinkled clothes and single, lonely socks when I arrive at any destination. Travel stresses me out. Months away from a trip I am all smiles. I plan and save, daydreaming about the adventure. But the night before any sort of exodus I'm probably panicking. I panic about abandoning my routine, leaving my cat, missing a flight—really any doomsday scenario you can imagine. The thing I always have to remind myself—and can't seem to remember until I return from said trip—is that value of escaping normality is what you're left with when you are back home. Shocking your routine and senses is the best thing you can do to kill a creative rut.

I live in the humid South, where summertime brings an elevated state of grumpiness to anyone who did not grow up sweating for a solid half of the year. Last summer we took a trip to Yellowstone. Leading up to the trip, I fantasized about wearing a sweater at nighttime in August. When we landed in the vast land of Montana, I felt my sense of curiosity renewed. I spent a week searching for wildlife, peering through binoculars instead of at screens. The mornings were dewy and cool, deer quietly moved in the yard outside the windows. I didn't once open an email. I spent time staring at the night sky. I just let the place take over my schedule. I made time for the Big Sky sunsets and I let the sound of mule deer calling in the yard wake me up early in the morning, rather than the honking of an alarm clock. It

was everything I'd hoped for and envisioned. For a week, I let every part of my life revolve around the sensory experience of minimal obligation and adventure. It was a delightful, idyllic vacation. Of course, not every trip is this grand. There are mini–family vacations I take several times a year, up I-77 to West Virginia. The route, the company and the home are familiar. Yet, when I return to my normal routine after these small and routine vacations, I still feel the same sense of peace and rejuvenation.

When you allow a pause—even if only a brief one—in the repetition, you come back to it with something new. It is the nature of life to add to our collective experience and let it color everything that follows.

Collecting Vacation

The best way I've found to hold fast to the memory of a place or experience on a vacation is to collect. I collect in these ways on trips large or small.

Sketching or Drawing

You can restlessly scribble on a plane, or tuck a couple of tools in your hiking pack for a nature excursion—collect visually by sketching. Just like the exercise of working on the blind contours, the greatest way to see something is to look closely.

Natural Souvenirs

Taking things (thoughtfully) from nature is a way to gather for future creative exploration and to recall the times you've spent away from the grind of work. When I spend a few days at the beach, there are always little treasures to be found on the sandy, grooved shore. Most people collect shells, or at least pick them up, turn them over and investigate little collections of mineral and rock. I am not a hoarder of shells the way I am of paper, but I do love to find little teeth along the coast. I'm never lucky enough to find a pearly white chomper, but usually I can spot the tiniest black fossil of a shark tooth in the sand. I keep them all in old film canisters—those little plastic ones with the gray lids. I have no plans for the teeth, they only live in a drawer to remind me of the time I've spent hunting for things lost or hidden: time not wasted, but time used to pause, look and gather.

Photographing Signs

Old hand-painted signs, big vinyl coverings that scale the sides of skyscrapers—any form of typographic communication in a new place can be interesting and memorable. Whether you're interested in typography or just remembering a place you ate or spent time at, photographing signage is a great way to explore a new place and understand the demographics of a particular area.

August 23, 2013 >>> 11:00 AM

This is a sketch I drew on the airplane ride to Bozeman, Montana.

I made these sketches and doodles during time spent resting after a hike.

I photographed these signs and typography in Montana.

More signs and typography from Montana.

CHAPTER TWELVE

stay curious

DURING THE SPRING AND SUMMER, there are families of bluebirds that live near my grandparents' house. They come to nest in a few generic birdhouses scattered throughout the yard. What the birds don't know is that my grandmother loves to feed them. She feeds them mealworms, set out on the deck in an old dish. The birds come as soon as they hear the clink of the ceramic dish. She watches them from the screened porch or the window, and they come back each morning.

After years of purchasing the mealworms from a local store, she decided to raise her own crop of mealworms. It was a tedious process that required making containers of oatmeal and apple peels, moving crawly beetles and larvae around daily, and placing containers of worms in the fridge when they had completed their cycle. The birds in the yard were quite happy with the harvest of worms and were soon unable to fly because they were so fat.

While the process of growing the mealworms was lengthy and at times burdensome, the reward was far more than just saving a couple dollars at the store. The care it took to invest in the time and energy to understand how the process works surely made the bond between bird watcher and bird a little stronger.

Staying curious about as much as you can is the key to discovering creativity. Especially in advertising, design and illustration, the work you create is most often not about your

insular industry. It's about everything outside of you and your job is to distill and relate all those things to each other. Without the drive of curiosity those connections are hard to come by.

I seek to satisfy my curiosity mostly through reading and listening; these are my favorite sources of knowledge.

- *Radiolab*
- *Morning Edition*
- *This American Life*
- *The New Yorker*
- *Esquire*
- *Vanity Fair*
- *CBS Sunday Morning*

CONCLUSION

optimistic discipline

WHEN THE SEEDS ARE PULLED from their packets and tucked into prepared soil, a sense of optimism is present. A positive outlook is important as the idea of something growing begins. There must be a joy that encourages the discipline of caring for something and seeing it through. There are always obstacles to just about any endeavor that involves process—a hot summer, too much rain, the burden of other duties—all things that can stunt the growth of a plentiful garden. But plants that are bending toward the ground or wilting in the sun can be revived, more often than not, with a little effort and a change in their care.

The key to maintaining the cycle of creating and enjoying what you make is simple. It's the discipline of being optimistic. I find that optimism is contagious and thrives at the start of something new, whether it is a project with an objective or something just for fun. At the first sight of something going wrong, there can be an oppressive feeling of failure, a crumbling of good intentions. Reflecting on past successes or simply focusing on the moment of *making* in the actual process pulls me out of the spiral of negative attitude.

The discipline of being prolific produces quantity, which then leads to quality. The simple idea of trying and trying again is a hardworking idea. Failure isn't failure if you can reflect, learn and grow. Failure is, in fact, a critical part of the process in allowing refinement and creating rituals that lead to creative exploration.

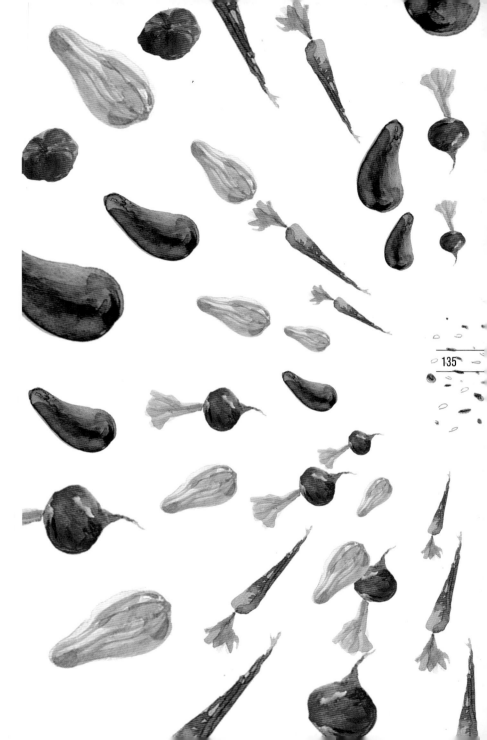

About the Author

Maria is an illustrator and designer who believes that smart ideas make beautiful work.

With affection for process, she works by hand, and then on screen for projects large and small while maintaining her daily illustration blog, *Wordless News. Wordless News* started as a side project of passion and visual exploration and turned into a large part of her routine and launched her editorial illustration career. Maria lives in Columbia, South Carolina, with her husband, cat and dog.

Index

More Great Titles from HOW Books

An Illustrated Journey
By Danny Gregory

Discover the artistic ideas behind the art journal pages of more than 40 famous and up-and-coming artists. Danny Gregory provides you with insights into private travel journals, helping you find artistic inspiration of your own. In each essay, the artist discusses experiences, materials and techniques alongside images shared from their personal art journals. If you love to travel and you love to create, then you'll love the inspiration provided in the pages of An Illustrated Journey.

Creative Workshop
By David Sherwin

Designers can often struggle to find creative inspiration because of tight deadlines and demanding workloads. So if you want to perform your best, then you need to exercise your creativity! Creative Workshop helps you do just that. Packed with 80 unique creative-thinking exercises that utilize all kinds of media and range in time limits (we know how rare free time can be), this book can help give your brain the creative workout it needs to stay sharp.

D30: Exercises for Designers
By Jim Krause

D30 contains thirty exercises designed to develop and strengthen the creative powers of graphic designers, artists and photographers in a variety of intriguing and fun ways. What will you need to begin? Not much. Most of the book's step-by-step projects call for setting aside an hour or two, rolling up your sleeves and grabbing art supplies that are probably already stashed somewhere in your home or studio—things like pens, drawing and watercolor paper, paints, scissors and glue. Try these hands-on exercises to unleash your creativity and get unblocked!

Find these books and many others at MyDesignShop.com or your local bookstore.

For more news, tips and articles, follow us at **Twitter.com/HOWbrand**

For behind-the-scenes information and special offers, become a fan at **Facebook.com/HOWmagazine**

For visual inspiration, follow us at **Pinterest.com/HOWbrand**